Photography and Science

exposures

EXPOSURES is a series of books on photography designed to explore the rich history of the medium from thematic perspectives. Each title presents a striking collection of approximately 80 images and an engaging, accessible text that offers intriguing insights into a specific theme or subject.

Series editors: Mark Haworth-Booth and Peter Hamilton

Also published

Photography and Australia Helen Ennis

Photography and Spirit John Harvey

Photography and Cinema David Campany

Photography and Science

Kelley Wilder

reaktion books

Published by Reaktion Books Ltd
33 Great Sutton Street
London EC1V ODX
www.reaktionbooks.co.uk

First published 2009

Printed and bound in China by C&C Offset Printing Co., Ltd

British Library Cataloguing in Publication Data
Wilder, Kelley E. (Kelley Elizabeth), 1971–
 Photography and science. – (Exposures)
 1. Photography
 2. Art and science
 I. Title
 770.1'5

ISBN: 978 1 86189 399 4

Contents

Introduction

Photography wasn't invented in the usual sense of the word. No technical breakthrough, patent, or person can be singled out as *the* invention or inventor of photography. The process of photography becoming photography was more an emergence, a layering of cultural happenstance, commercial pressure, political power and individual curiosity. Nonetheless, various dates have been important to photography, and 7 January 1839 is one of them. This was the day of the first announcement of the daguerreotype to a larger public. 'Larger' has to be taken relatively in this case, as does 'public'. The daguerreotype was announced to the Paris Académie des Sciences, and most of those present at the announcement were scientists, which hardly qualified them as representing the general French public. So photography's first public steps were made in the halls of science – does that mean all photography is scientific?

Surely the literature is confusing enough. 'Photography is a science!', asserts one source, 'Photography is an art!', counters another, both sides working the apparent mutual exclusivity of the two categories. Histories of art pay scant heed to the technical innovations required to make the images that compile their canon. Histories of science have stuck mainly to the technology that is photography, often suppressing the role of images.[1] But histories of photography have often fared no better in trying to toe this imaginary line that appears to divide two spheres but lands precisely in the middle of the medium of photography. This book is ostensibly about the coming together of two fields of study – science and photography. But there is no proof that a sharp divide ever existed between art and science, or between science and photography. Even the

1 Photographer unknown, *Autoradiograph of di-deoxy sequencing gel*. Di-deoxy sequencing is a way to determine the order of bases (A, C, G and T) in a piece of DNA. The autoradiographs are made by marking each sequence with a radioactive isotope that exposes on a photographic emulsion.

final chapter, 'Art and the Scientific Photograph', is meant to show how artificial the divide *has always been*. Images tagged as science and images tagged as art are labelled by their audiences, not by some inherent quality of the images themselves. The relationship photography and science have with one another is no one-way street. It is an ebb and flow of influence, information and innovation. Photography would not exist but for scientific investigation, and science would hardly have the form it has today without photography. This book is a short introduction not only to the sorts of images associated with science photography, but also to the symbiotic relationship between the development of science and the development of photography. At its core lie some persistent questions: what is a scientific photograph, or photographic science? What is the relationship between photography and science – and moreover, why should it interest us? Is 'scientific' a genre of photography? Does 'photographic' describe a type of scientific method? Although there is no catalogue of answers provided in this book, each chapter presents different ways of dealing with these questions.

In this history, science is not only the beginning of photography, but is also its end. It is admittedly only one way of telling the history of photography, and ignores many other important developments. There there are three main themes that recur in the text: the representation of scientific objects or phenomena in pictures; the use of photography to detect and measure phenomena; and the development of photography as a science. These three themes will appear again and again at various points in the coming chapters.

Like many things when they are first invented, it was not exactly clear where or how far photography would go. Although some commentators, among them William Henry Fox Talbot, François Arago and Sir John Herschel, had high hopes, and wrote reams of predictions about the 'new art', it was actually some time before the potential of photography could be realized in many sciences. In some areas photography never achieved these predictions; in others it far outstripped them. This introduction is about how photography got started in its various roles in science, and how we came to speak of it very often as a science.

Trust

On a Monday in Paris, 7 January 1839, François Arago, Permanent Secretary of the Académie des Sciences, Director of Observations at the Paris Observatory, finished describing the 'beautiful discovery made by Mr Daguerre' to the assembled members of the Académie, and Jean Baptiste Biot, Professor of Physics of the Collège de France, sometimes colleague, sometimes rival to Arago, took the floor. He could 'no better express his thoughts on this invention than to compare it to an artificial retina placed by Mr Daguerre at the disposal of physicists'.[2] This eye metaphor is still in use today, even though photography has changed quite dramatically in the intervening years.

Linking the human eye with the acquisition of knowledge is a practice as old, if not older, than the philosophy of Plato. In the seventeenth century the Cartesians, beginning with Descartes (although he had his eye-analogy from Johannes Kepler), introduced the notion of the eye, along with the rest of the body, as a sort of mechanical tool. In this case, it was the eye-as-camera-obscura, and it was a mechanical tool used primarily for observing and learning about the outside world (illus. 2). The camera obscura had long been in use by Descartes' day, and its model of projection was a model that helped to explain the workings of the eye. Surprisingly, because the camera is monocular and most humans are binocular, the camera slowly came to represent the way 'vision' worked. According to this account, the images from the world are impressed on our retinas, upside down and backwards, and the function of the optic nerve and the brain behind it is to right the image and flip it front to back. Although vision is no longer conceived in this way, it is still no great leap to see how photographing something came to be tantamount to seeing it with your own eyes.

The metaphor of the artificial retina is far too complex, however, to be explained away so one-dimensionally. It grew in complexity and strength as the number of instruments for looking at the world multiplied. Peeping through the eyepieces of microscopes, telescopes and camera lucidas or looking at the projections of the magic lantern or camera obscura provided scientists and artists with a new, extra-ocular way of observing the world.

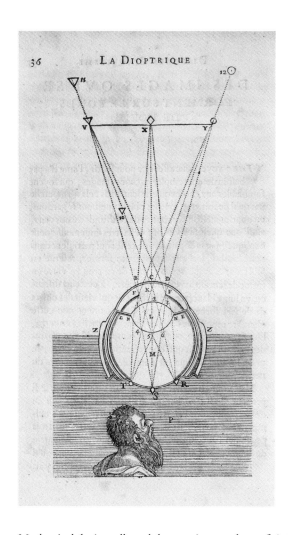

2 René Descartes, *la Dioptrique*, illustrating Kepler's ocular dioptrics, camera obscura using the eye of an ox, 1637.

Mechanical devices allowed the growing numbers of sixteenth- and seventeenth-century scientific observers to come closer to the great demands of ideal observation – looking without bias, fatigue or theorizing. The in-fallible vision expected of virtuous observers was often achieved with the aid of devices, many of which were laden with the eye, or artificial retina, metaphor. The ultimate goal was to capture what was cast on this retina.

 The images cast by projection devices like the camera obscura and magic lantern were like jewels – the intense colours mysteriously heightened

by the darkness in which they appeared. The mere idea that one of these images could be fixed in all its glory stirred the imaginations of many scientists and artists well before 1839. The phrase 'artificial retina', became almost a catchphrase, as did the adoption of the camera, and later, by extension, photography, for scientific looking. Biot's expression was no more than a verbalization of ideas that had been circling one another in Western thought for centuries. They are ideas that fed, and still feed, the debates about photographic veracity and mendacity that crop up regularly in scientific photography and in photographic science.

The photographic-medium-as-scientific-eye metaphor is directly derived from the camera-as-eye analogy and is one of the tools that bolsters our trust in the photographic image. You have to 'see' something in order to 'believe' it. This holds even when the photography in question didn't employ a camera at all. A Lichtenberg figure made on a photographic plate has come to represent how the flow of electricity would look if we could see it (illus. 3). Yet Lichtenberg figures, like many scientific photographs, are made without the use of a camera. The electricity is discharged directly on the photographic emulsion, and rushing electrons create a pattern directly on it. In this way, the photograph acts more like human skin than the human eye. If lightning strikes a person, these same tracks sometimes appear on the skin of the victim. Although cameraless images do act more like skin than eyes, the eye analogy of the camera is still the one predominantly used, and it can be found sprinkled throughout texts about science photography. Photograms, images made without a camera, are a staple of science, although they are never called 'photograms', as they would be in an art context. They are just science photographs.

In photograms, photography, specifically the photographic emulsion (either on a glass plate or on a celluloid film), is treated as a registration instrument. Like tidal gauges, thermometers and Geiger counters, photography records some stimulus, rendering it not in numerical or audible fashion but as visual images. It is transparent insofar as it appears so straightforward, so mechanical, so easy to control. Photographic methods were developed to record all sorts of stimuli, from earthquake tremors to the human pulse (illus. 4). The photographic emulsion is not, however, quite as simple a machine as it is sometimes portrayed.

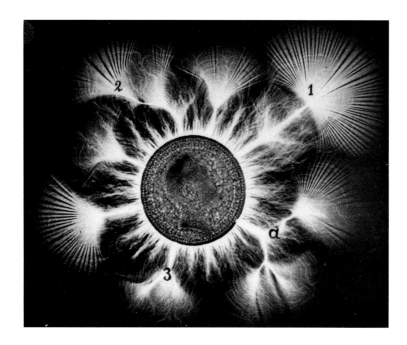

3 Anton Blümel, *Lichtenberg Figure* (using a coin), c. 1898.

In the early decades of photography it was not the automated picture-making enterprise it is today. It was still a craft of enormous delicacy and great variability. It was really only in the twentieth century that photography could be accurately and easily standardized. As a result of the variability of emulsions in the nineteenth century, discussions and arguments about how far photography could be trusted were common in the scientific community. Each new photographic method was not just taken at face value, but was explained, controlled, verified and re-verified. Every emulsion was tested in endless combinations of lighting and development. Ironically, photography was often used when investigating the workings of photographic emulsions. Photographic science relies on photography as not only the subject, but the illustrator as well (see illus. 11). Photographic illustrations of photographic science are also scientific photographs.

What exactly is the difference between scientific photographs and photographic science? It seems wilfully obtuse to say that sometimes there is no difference at all, although it is too often true. A photograph of diffraction in exposed silver iodide is both a photograph of the

4 The photographic method of recording the pulse wave, by Stein, from Marey's sphygmograph, 1885, reproduction of an engraving.

Annalen d. Phys. u. Chem. Bd. LXVIII. Taf. I.

viol.

roth

Fig. 1. Fig. 2.

viol.

roth

Fig. 3. Fig. 4.

Fig. 5.

H. Scholl.

Annalen d. Phys. u. Chem. Bd. LXVIII. Taf. II.

III.

II.

I.

Fig. 6—8. Fig. 9—11.

H. Scholl.

5 Hermann Scholl, *Über Veränderungen von Jodsilber im Licht und den Daguerreschen Process* (Changes in exposed silver iodide and the Daguerreotype process), 1899, photomechanical print.

workings of the daguerreotype emulsion and a photograph of diffraction (illus. 5). In this book, I have made a rough distinction between the two. Scientific photography is the use of photography to represent scientific phenomena, and photographic science is the investigation of any part of the photographic emulsion in the attempt to find out just what is happening when a photograph is made (after exposure, development or fixing). In very large part it is photographic science, also known as emulsion science, that has helped to make science photographs more trustworthy.

The more that is known about the workings of the photographic emulsion, the better it can be controlled in scientific use. Chapters One and Two, on observation and experiment, detail many instances where either trust or mistrust is built on the inner workings of photographic chemistry.

Illustrating Science

If the boundaries and nature of photography were unclear in 1839, so too were the boundaries and nature of modern science. On 7 January, neither the word 'photography' nor the word 'science' were used to describe what we today think of as these two diverse fields. They have matured together, consolidating themselves in the minds of their audiences. Most of this,

6 Photographer unknown, *Nature*, a pair of comparison images, showing the absence and presence of Nova Aurigae, the spectrum of Nova Aurigae, and the spectrum of the new star in Aurigae, as compared with the spectra of plantary nebulae (this last taken by Jenő Gothard), 1895.

7 Photographer unknown, *Nature*, cover, 23 August 1969, showing the use of scientific photography in advertising and marketing the magazine.

although not all of it, took place through the publication of many scientific photographs in both specialist and popular journals of science.

The role of the illustrated press in propagating both modern science and photography has been well discussed.[3] The role of the three put together is still somewhat shadowy. Perhaps *Nature* is the best example. Today *Nature* is exceeding its 7,000th issue, having been first produced in 1869. It billed itself, then as now, as the weekly illustrated journal of general science, providing an overview of all sciences, not just a specialized look at one. In the 1890s the magazine began reproducing photographs on its pages to accompany drawings, etchings and lithographs (illus. 6). By the 1950s photographs appeared at regular intervals. By 1970 the photography had migrated to the front cover, first in advertising and eventually showing an iconic image from one of the articles (illus. 7). The glossy magazine we know today, with its multiple, overlapping colour images, is a far cry from its largely text-based origins. With the increasing use of photography as a vehicle for science to communicate its message to the public, one would think that the dialogue about photography's role in the sciences would also become more intense. But this is not the case. By the early twentieth century, the presence of photographs in nearly all branches of science was taken as a given. Individual photographs might be questioned, retouching might be frowned upon, but still, photography as a whole retained its place securely. How did it do this?

The usual way to go about discussing photography's relationship with science is to tell the history of the use of photography in illustrating various disciplines of science. Although this method has achieved some much needed overview of the history of photography in science, it hardly begins to scrape the surface of the relationship of science as a whole with photography as a whole.[4] And it doesn't answer the crucial question of how photography, with all its faults, has retained its place for so long in the sciences. The issue is not when and how a photograph of Jupiter was made, or why one exposure has been removed from the plate before printing (illus. 8). Although these details are important as well, they are not the focus of the current volume. This is a book about the possible connections between Paul and Prosper Henry's astronomical images of the nineteenth century and an anonymous sheet of film from the late twentieth century, showing DNA (see illus. 1).

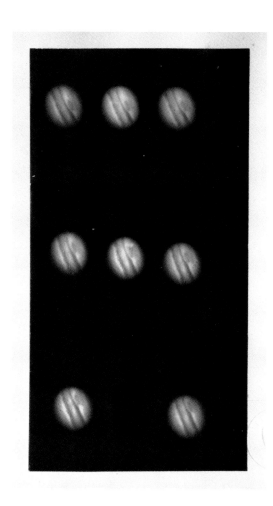

8 Paul and Prosper Henry, *Jupiter, with one exposure erased*, 1886, albumen print.

These connections are the key to understanding photography's robustness. To this end the book is divided according to several important concepts that concern all scientific disciplines: observation, experiment and archiving. Within the discussions of these larger concepts are also numerous 'smaller' ones, such as trust, evidence, control and success and failure. Chapter Four returns to all these themes by taking up the oft-debated theme of art and science, where photography acts as the fulcrum supporting a dialogue, and more importantly, an exchange of methods and ideas (illus. 9).

9 Claudia Terstappen, *Wet Specimens*, 2007, C-print, 156 x 150 cm.

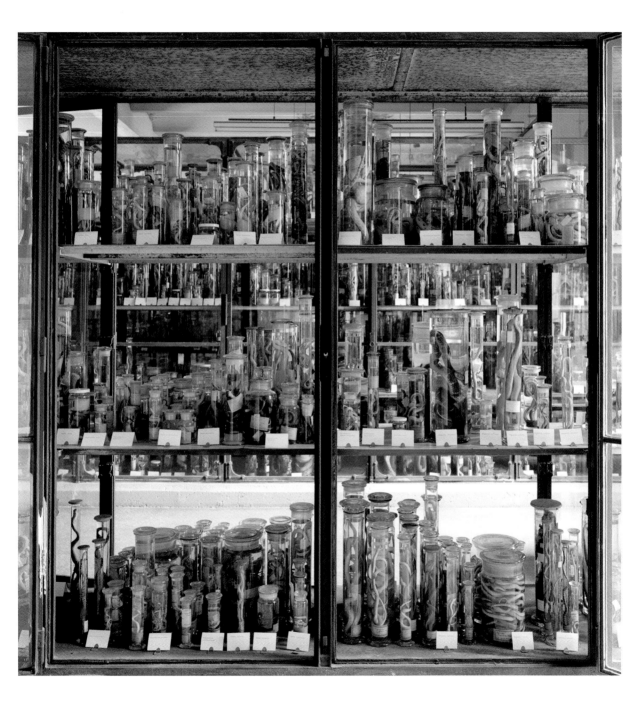

Photography and Observation

Nothing is real unless it is observed.
John Gribbin[1]

Part of the enthusiasm for photography in 1839 was engendered by its
claim to fulfil so many of the criteria deemed necessary for good scientific
observation. It was mechanical, and so indefatigable. It was indiscrimin-
ate, and therefore objective. It was optical, and consequently reliable.
Or so went the rhetoric. Through the eighteenth century the use and
reputation of observation, as opposed to theory, in the sciences had been
steadily on the rise. Observing was considered an art, reserved for those
exceptional, diligent and above all sharp-eyed devotees of the natural
world and the heavens. To name oneself an artistic or scientific observer
in the first, pre-photographic decades of the nineteenth century was to
aspire either to the nearly mythical fame of enlightenment observers
like Senebier or Linneaus, or to emulate the extraordinary (possibly less
attainable) Renaissance observers of nature and the human form,
Leonardo and Michelangelo.

Nineteenth-century cultures of observation were powerfully pervasive,
and they left a clear signature on the development and use of photography,
not to mention its rhetoric. The inventions and innovations of photography,
in their turn, influenced the way scientists observed, and restructured the
hierarchy of observations scientists held to be valuable. Pre-photographic
scientific observation required not only years of painstaking acquisition
of skill, but an innate genius for concentration and attention to detail.
Photography promised these skills to those who lacked such training,

while at the same time upholding the high standards that had been set by able observers of the past. It also temptingly collapsed the separate processes of the act of observing into the reliable recording of observations. This eliminated the aggravating need to momentarily take one's eyes off the subject while jotting down notes or sketches. Photography 'recorded as it looked', and scientific photographs can be seen as consisting largely of these sorts of recordings. But perhaps photography's two most seductive claims, and those most often associated with observation, were the promise of passivity and the extension of the realm of the visibly observable.

Complete passivity, the damping down or elision of subjective decisions by scientists in the illustration of an observation, became so desirable to those striving for objectivity in their representations of science that it was (and for many decades remained) a powerfully active metaphor even in the face of significant evidence to the contrary. The notion that photography was inherently passive was quite likely the single greatest stumbling block for advocates of art photography in the second half of the nineteenth century. It was also the key to George Eastman's wildly successful advertising campaign for the first Kodak camera, 'You press the button, we do the rest'. In science, it was the foundation on which photography was based, and any threat to that foundation revealed a coincident threat to the paired notion of objectivity, especially mechanical objectivity.[2] As pervasive as the notion of passivity was and is, photography's real calling card is its reputation for widening the scope of what could be observed by the eye. Ultraviolet radiation, called variously the chemical spectrum and the actinic spectrum, formed the basis of nineteenth-century photography. When it was found that photography was also sensitive to a whole host of other 'invisible' radiation in the 1890s, the discovery did no more than reinforce Talbot's opinion, written in 1844, that 'the eye of the camera would see plainly where the human eye would find nothing but darkness'.[3]

To the consternation of scientists, the practicalities of photography in the real world deviated, sometimes uncomfortably far, from the theoretical ideal. It was often the case in the nineteenth century that professional or amateur photographers were hired to work side by side with astronomers, microscopists and surveyors, adapting their knowledge to

science actively kept photo back?

specialist instruments. In each instance, the record produced by photographic observing needed consequently to be understood against the background of the technical parameters of photographic capability, the operational setup and the ability of humans to interpret what they saw on the photographic negative or positive. With so many variables, it is hardly a wonder that photography was not quite the unqualified success it was often hailed to be. Nonetheless, scientists and photographers persisted in their attempts to wrest ideal, objective and clearly legible images from the photographic medium.

Emulsions, Emulsions, Emulsions

> Some gentlemen apparently seem to find this albumen-beer process not [the] answer, and lay the blame on the beer . . . One thing, I think, may affect sensitiveness, and that is the collodion. I make mine rotten with water and then add the same unwatered collodion to it till all 'crappiness' disappears from the film. I lay great stress upon this point, as I believe the constitution of the pyroxyline is altered by it, and certainly the film becomes more porous.[4]

Experimental emulsions are not confined to the nineteenth century. At a stretch, one could count the work done by Elizabeth Fulhame and others in the latter half of the eighteenth century as emulsion research, and could certainly include the development of nuclear, x-ray and other specialized films in the early and mid-twentieth century.[5] The specially-devised, hand-made, specific emulsion remained an important component of scientific photography long after the three largest companies, Kodak, Agfa, and Ilford, had succeeded in standardizing most day-to-day film use. Many of the most specialized emulsions were made to order by these same companies.[6] With new emulsions came adjustments in the evaluation of observations, and many conflicts about the 'success' of a given observation when it was conducted photographically. This is why there often seem to be conflicting opinions about the usefulness of photography in the sciences. 'It is a success', say some, 'It is a failure',

contradict others. The true measure appears to lie somewhere in the middle. Often an enterprise was a photographic success story even while it failed to produce the desired scientific data.

Some of the earliest debates on the subject of emulsions and emulsion speeds (here used interchangeably with 'sensitivity'), and consequently success and failure, appeared in the context of astronomy. A great many household names in the history of photography have been associated with astronomical images: William de Wivelselie Abney, E. E. Barnard, William Crookes, L.J.M. Daguerre, John Draper, Paul and Prosper Henry, Jules Janssen, Hermann Krone, Adolphe Neyt, Warren de la Rue, Lewis Morris Rutherfurd, Hermann Wilhelm Vogel and John Adams Whipple, to name a handful. Much of their work revolved around adapting emulsions and photographic instruments to astronomical observation, and they produced everything from spectra of starlight, to photometric readings, to iconic images of the heavens (illus. 10).

In the 1870s and '80s photographers' theories and innovations, which had been published and discussed in scientific and photographic journals for several decades, were brought together in one of the most prominent international debates about photographic observation – the discussion about the use of photography in observing the two transits of Venus of 1874 and 1882. The collective observations were massive undertakings, underwritten by each respective government, in which hundreds of individuals dispersed around the globe in search of the perfect viewing station. In 1874 alone, expeditions were sent by the British, French, Russians, Italians, Americans, Germans and Dutch. Partly because the expeditions were so public, and partly because they were so contentious, they provide an excellent record of the sorts of photographic concerns that astronomers felt were the most pressing. Much of the debate centred on the viability of measuring the resulting photographic plates to extract an accurate indication of parallax, giving the scientists the tools with which to mathematize distances in space. In the end, it was the contentious issue of exactly how to measure the plates that led to astronomers' dismissal of the photographic results.

In 1874, one could either observe the transit or photograph it, but one could not do both at the same time. The photography was so complex,

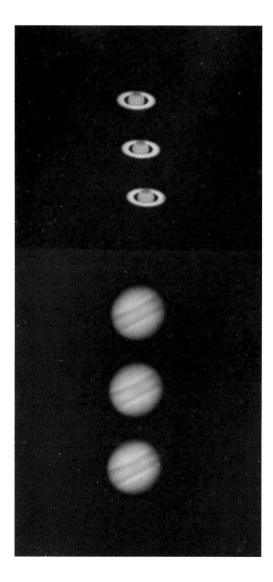

10 Paul and Prosper Henry, *Photographs of Saturn and Jupiter*, 1886, albumen print.

and needed such careful supervision, that the photographer's attention was trained mostly on the photographic task and only partly on the transit itself. A decision had to be met, not only about who would make the photographs if the observers were busy with their own instruments, but also whether or not it was worth the effort of training and equipping

photographers to accompany the observers at all. The resulting photo-graphic record would also need to be standardized across viewing stations so as to make them comparable, and standardization was not one of photography's strong points.

Consider the problem. What would it take to create an effectively measurable photographic plate in 1874? Commercially made, standardized, gelatin dry plates were still some decades off. Daguerreotypes, although considered somewhat old-fashioned by photographers of the 1870s, were nonetheless very practical for science. The silver-coated copper plates could be rough-polished and transported in cases. The necessary chemicals, iodine and bromine crystals and mercury and gold solution were half crystalline, so the darkroom procedure could be conducted with relatively little water. Fresh, clean water was always a problem on expeditionary travels, certainly no less so if it was needed to prepare uncontaminated developers and fixing baths. One particular advantage of the daguerreotype lay in the opacity of the plate. There could be no internal reflection in a metal plate. This problem of internal reflection, and the lack of clarity it might cause in the resulting images, was of more concern to scientists than any question of sensitivity or dimensional stability, although those were factors as well. In the end, it was the daguerreotype's huge power of resolving fine details that ensured its usefulness for creating measurable records. When in the late 1970s and early '80s scanning electron microscopes were turned on daguerreotype images, they revealed some secrets of this fine detail. (Before this time, daguerreotype emulsions had been investigated, but the image particles were smaller than the resolution of the strongest available microscopes). The analysis of the silver-mercury and – in the case of gilded daguerreo-types – silver-mercury-gold amalgams creating the emulsions revealed that chemically and physically, the micro-structure of the image surface differs from one part of the image to another. This together with the minute size of the image particles lends the perception of near-magical, endless detail that so captured the public's imagination in 1839 (illus. 11).[7] Measurements of these details could be trusted, or so believed the French in the nineteenth century, who largely employed the daguerreotype in their transit expeditions.[8]

cool

overleaf: 11 Dr Susan Barger, *micro-structure of a gilded, mercury-developed daguerreotype step tablet, with high and low magnifications*, c. 1991, photograph of a daguerreotype emulsion made with a scanning electron microscope.

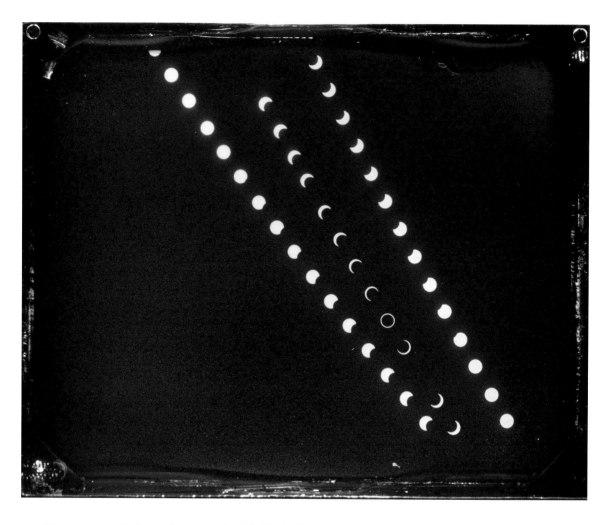

The more sensitive but rather unpredictable 'dry' collodion method also had its advantages. Chief among them was the speed of the emulsion. Although wet collodion plates could produce some very fast emulsions, it was obvious that photographing the transit on a still-wet emulsion, one that would then be developed, fixed and dried, would not render scientifically viable measurements. Dry collodion plates were considered more stable dimensionally, and could be prepared at home for use on the transit a month or more later. The British expedition photographers were all

12 Robert Schlaer, *Annual Solar Eclipse from Santa Teresa, New Mexico*, 5 October 1994, multiple exposure daguerreotype, taken at five-minute intervals, 4 x 5 inches. Although this plate was not made with a Jansen instrument, it shows the advantage of multiple exposure images of astronomical events.

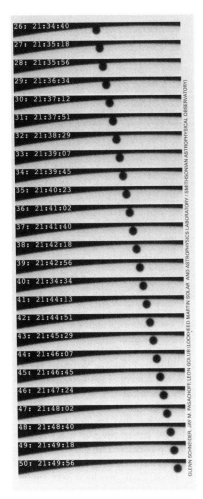

26:	21:34:40
27:	21:35:18
28:	21:35:56
29:	21:36:34
30:	21:37:12
31:	21:37:51
32:	21:38:29
33:	21:39:07
34:	21:39:45
35:	21:40:23
36:	21:41:02
37:	21:41:40
38:	21:42:18
39:	21:42:56
40:	21:34:34
41:	21:44:13
42:	21:44:51
43:	21:45:29
44:	21:46:07
45:	21:46:45
46:	21:47:24
47:	21:48:02
48:	21:48:40
49:	21:49:18
50:	21:49:56

13 Glenn Schneider, Jay M. Pasachoff and Leon Golub, *Transit of Mercury*, TRACE image, 1999.

trained in the dry collodion technique. This was not the end of the debate, however. Once the emulsion type had been chosen, there were three possible methods of exposure. There was the so-called 'Janssen' plate, where as many as 50 exposures could be made on one plate (illus. 12). This method, often considered a forerunner to cinema, was eventually developed into instruments like TRACE, the white light optical telescope used to make images from space of, among other things, the transit of Mercury in 1999 (illus. 13).[9] Images could also be made in stereo, or one exposure per plate could be made serially and the measurements could be reduced along with other eye-observations (illus. 14).[10] Each of these methods has its advantages, but by far the most prevalent was the one-exposure-per-plate method. The six negatives here, taken by different photographers at different stations, exhibit a range of both colours and densities, although they were made after the same method and intended to be uniform. They testify to the extreme difficulty of photographing any astronomical event.

William de Wiveleslie Abney was stationed in Egypt for the 1874 transit.[11] He brought with him two types of dry plates, collodio-albumen (the albumen beer process) and a form of collodio-gelatin plates, as well as the chemicals to make both on site. Recipes varied among daguerreotypists, but not as widely as they varied for dry collodion. Because collodion becomes impervious to liquids when dry, 'dry' collodion wasn't any such thing. It was a collodion emulsion that was treated with honey, sherry, syrup, beer or any number of sticky substances. These humectants retained moisture, preventing the emulsion from drying out completely. Different photographic recipes delivered different results, and this meant different colours and sometimes quite different sensitivities. Pure collodion emulsions were faster than pure albumen emulsions, but when collodion and albumen were used together, usually the result was faster than either used separately. The unknown quantity with the use of each colloid, whether it was albumen, collodion or later gelatin, was its effect on the sensitivity of the entire emulsion. It was a problem that baffled photographers and scientists until well into the twentieth century. Gelatin turned out to be not only practical, because it could be dried and later wet again, but also faster, because gelatin positively affects the sensitivity of silver halides.

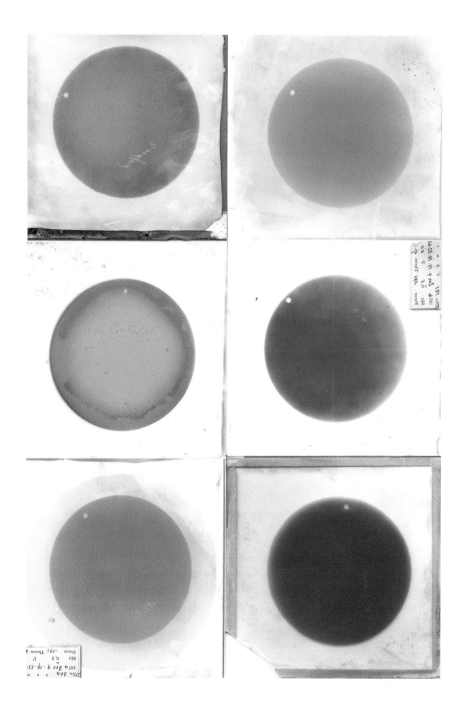

14 Six glass plate negatives of the 1874 Venus transit made by British photographers on various expeditions, 1874, glass plate negatives.

Speed did not mean a sacrifice of quality or greyscale, at least not in the case of Abney's recipe. The collodio-albumen emulsions were favoured for their tonal scale by many landscape photographers in Britain from the late 1850s onwards. The albumen-beer process, a variant of collodio-albumen, was Abney's own invention, developed some time in 1873 and taught to all of the British expedition photographers of 1874.[12] His defence of the emulsion, cited above, reveals a deep-seated anxiety about the level of standardization that could be effectively achieved. Abney trained the British photographers, who were then dispatched with similar equipment, similar observatories and similar chemistry, right down to the Tennents. The photographers were militarized, even if they weren't paid members of the military. They were taught at the School of Military Engineering at Chatham and sent with military assistants who recorded the transit with military timing, preparation, exposure, storage and later development of the plates.

Even with all this British military prowess, they still had no control over the weather. Abney despaired when his developing baths, 'which suited daywork, were too weak for the cold of the night, and it was too hot to prepare the plates during the day', and 'the dust interfered, and we were obliged to wait for the dew to lay it before we dared venture on preparing a large batch. We had trial after trial. As fast as one difficulty vanished another made its appearance.'[13] Abney counted the expedition a success. He and his military team exposed 45 plates, several of them Janssen plates with 50 exposures each. The *London Illustrated News* also hailed the transit photography (collectively) as a success.[14] The astronomers, however, deemed the photographs failures. In spite of all attempts at standardizing the effort and orchestrating the photographic training, the reliable data set they hoped to create was not forthcoming. After lengthy discussions at Greenwich (where G. B. Airy, as the Astronomer Royal, was in charge of the observation reductions) about how to measure the plates, and with what instrument, the results revealed a parallax measurement significantly different from that achieved by the other observations. They were then measured again, using a different method, again with unsatisfactory results. The anomalies were put down to everything from irradiation to atmospheric distortion, but the real cause was never ascertained. The fact remained that the planetary definition was far

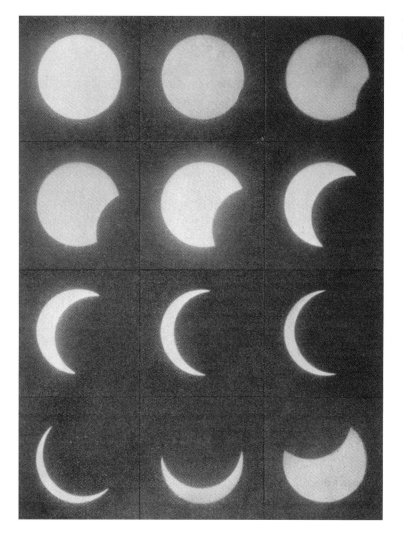

15 August Hagenbach, *Solar Eclipse of 1912*, made using Agfa Chromo-Isolar plates with a yellow filter, 1912.

too soft for accurate measurement. In one early exposure, Venus appeared to be 'square with rounded corners'.[15] In total, the British transit photographers made hundreds of images of the transit, but these images were not considered in the final result of the transit project.[16] The measurement of photographs of astronomical events remained difficult even when it appeared that the theories of measuring had been resolved. In 1912,

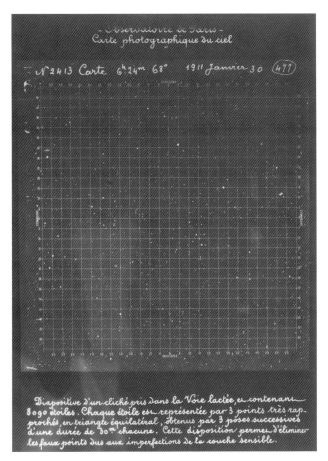

16 Photographer unknown, *Carte photographique du Ciel, No. 2413, Carte 477, 30 January 1911*, print made from a negative taken in the Milky Way, containing 8,090 stars. Each star is represented by three points very close to one another, forming an equilateral triangle, which were obtained by three successive exposures of a duration of 30 minutes each. This method allows for the elimination of phantom points arising from imperfections in the emulsion.

August Hagenbach photographed the solar eclipse with an eye toward generating exact measurements of the moment the moon began to slide in front of the sun (the moment of contact) (illus. 15). Although he developed a means by which the measurements could be made, his own images were, like the transit images, insufficiently sharp – a fault he put down to a loose camera mount but which could have been due to any number of factors.[17]

This failure of photography in the transit of 1874 did not signal the death knell for photographic observation in astronomy. Nor did it seem a great impairment to the general impression that reliable, measurable photographic observations could be made, both in astronomy and elsewhere. It would only be a matter of how and when. Only 13 years later, in 1887, a group of scientists met in Paris to form the Carte du Ciel, one of the most influential photographic observation projects in astronomy. This project to measure and map the heavens continued for nearly a century, providing an astrographic catalogue of millions of stars used to the present day. Carte du Ciel images begin their existence as individual observations, and carry on their working lives as part of an enormous observation archive. The photographic plates, once observations themselves, are observed again and again, always with different questions in mind (illus. 16). What is most striking about the Carte du Ciel is not just the idea of picturing millions of stellar objects, but the initial purpose, which was to observe and measure all stars over the eleventh magnitude. In this particular case, measurement was two-fold. Not only were stars compared to one another to determine their brightness, after which they were classified into magnitudes, but each star was also located in relation to its neighbours. Measurement, as we have seen in the story of the transits, often goes hand in hand with photographic observation.

The Impulse to Measure

From the moment photographs arrived on the scene, there has been an impulse to measure them in one way or another (illus. 17). This impulse is perhaps a by-product of the sometimes overwhelming specificity of photographs. A photograph like C. F. Powell's image of tracks of fission of uranium is not only a record of a specific event that occurred at a specific time, but also a record of the capability of one film emulsion (in this case Demers' Emulsion II, a diluted emulsion) to record a track with greater specificity than an emulsion of regular strength. The image represents a particular event – the collision of a fission fragment (at the left) with a nucleus in the emulsion at g.[18] It is the particularity that makes it possible to 'observe' the distance of the forked track to the right, through 1 cm of air, as shown at the scale at the bottom of the image. Curiously, the photograph is able to do this *even though* it shows how much variation occurs from one emulsion to the next. As we will see in the next chapter, it might be able to do this *because* it shows the variation between emulsions.

Scientific images have not always been made to measure. In the eighteenth century and before, the majority of scientific images were 'ideal' or

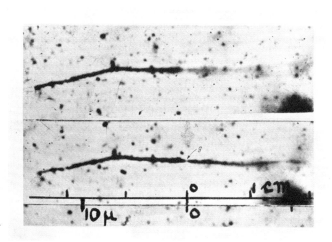

Tracks due to the fission of uranium

PLATE 2–1

Demers' Emulsion II. DEMERS (1946).

17 C. F. Powell, *Tracks due to the fission of Uranium*, Demers' Emulsion II, 1946. To achieve this, Demers 'sandwiched' layers of ammonium uranate between emulsions.

18 Maria Sibylla Merian, *Peach and Oak Egger*, after 1705, watercolour and gouache on parchment.

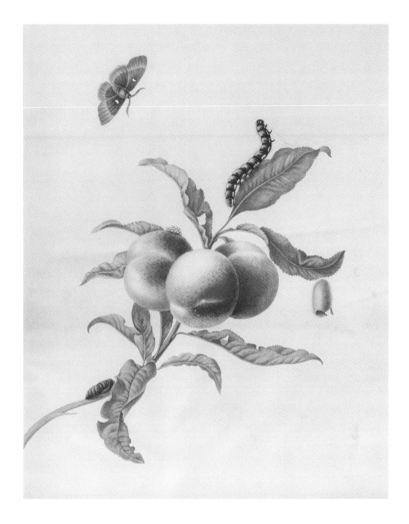

'reasoned'.[19] These images were true and scientific representations of nature, just like photographs, but they relied on an entirely different understanding of the truth claims. Maria Sibylla Merian's drawings of botanical and zoological specimens in the eighteenth century are an example of these sorts of images. Here she has drawn the various stages of an oak egger moth in its habitat (illus. 18). Botanical specimens were also often drawn as one plant with buds, flowers and leaves as seen throughout the growing season. Scientists of the day felt that only by examining many

examples could they recreate a representation that was true to nature. True, that is, to the underlying nature of the specimen.

Photographs have the knack of doing quite the opposite. They depict the specific object at a specific time and in a specific place. That is not to say that ideal photographs don't exist; they surely did and do, in both art and science. (For instance, in Francis Galton's or Henri Becquerel's work; see illus. 31 and 41). But the impulse to measure photographs rests on the premise that a particular object has been depicted, and that measuring it will tell you something about that object. Sometimes, like Talbot's counting 'about 200' panes of glass in his negative the *Latticed Window*, the ability to measure appears to be a useful but unintended byproduct of a photographic image made for other reasons (illus. 19). Often, however, photographs were produced specifically to be measured, like the Venus transit plates, or the star charts of the Carte du Ciel. The very notion that photographs could possibly be measured forms the foundations of various types of scientific photography, such as Raman spectroscopy and photogrammetry, two methods that bent photographic observation to mathematization. Surveying, for instance, is heavily dependent on the idea of measurable photographs, as is cataloguing museum objects by photographing them, and documenting archaeological sites. In the late

19 William Henry Fox Talbot, *Latticed Window* (with the camera obscura), 1835, photogenic drawing negative.

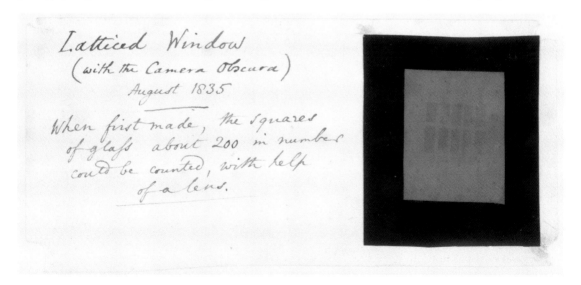

nineteenth and early twentieth centuries, people of all sorts were photographed and measured (see illus. 57). Microscopically, photography has often been used to produce an exact measure of its own particles (see illus. 11); or a nuclear event (see illus. 17); earthquake tremors; or the human pulse (see illus. 4). Often images made to be measured, like earthquake tremors or spectrograms, aren't considered photography at all. They use photography, but produce images that don't appear to depict anything recognizable. Even when they are recognizable as pictures, the images are often strangely distorted. Both Raman spectroscopy and photogrammetry created successfully measurable photographs, one producing extremely unconventional records, the other much more pictorial images.

In the early part of the twentieth century, C. V. Raman began publishing his results on obliquity factors of diffraction, measured photometrically (illus. 20). Measuring diffraction in this way, using both solar light and x-rays, became a dominant practice in spectroscopy, and led to notable studies of objects at the structural level as well as the molecular level (illus. 72). Raman photometric images resemble the stripy maps of the spectrum, or in the words of one spectroscopist, a supermarket bar code (illus. 21).[20] Unlike spectral maps, however, the information in Raman images was contained in the diffraction measurements, not in the visual

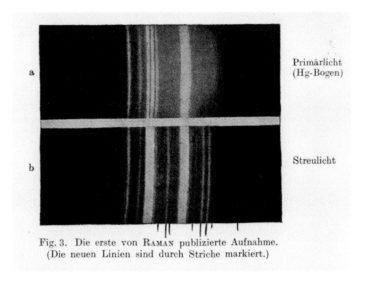

20 Chandrasekhara Venkata Raman, Raman's first published image, 1928, photomechanical reproduction.

Fig. 3. Die erste von RAMAN publizierte Aufnahme.
(Die neuen Linien sind durch Striche markiert.)

Primärlicht
(Hg-Bogen)

Streulicht

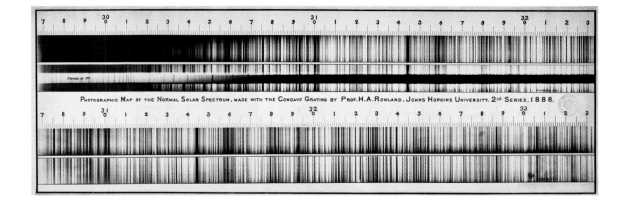

PHOTOGRAPHIC MAP OF THE NORMAL SOLAR SPECTRUM, MADE WITH THE CONCAVE GRATING BY PROF. H.A. ROWLAND, JOHNS HOPKINS UNIVERSITY. 2ᴰ SERIES, 1888.

form (illus. 22). These Raman plates were exposed over extremely long periods of time, utilizing the invaluable quality of photographic emulsions to gather light over periods of hours or even days. In this respect the discussion of emulsion speeds can be highly deceiving – giving the impression that 'fast' or 'sensitive' plates are always associated with short exposure times. In some sense they are, but even short exposures for some types of scientific photographs can still take hours or days rather than 1,000ths of a second. William Crookes took two days to expose his piece of pitch blend on a photographic plate (see illus. 38) and one image from the Carte du Ciel (see illus. 16), comprises in total a 90-minute exposure – three different exposures of 30 minutes each.

Raman plates are formed when monochromatic light is scattered over a molecule. Most of the light continues in its same wavelength, but a small amount is scattered sideways in different wavelengths, producing a spectrum that can be fixed with a photographic plate. It is then measured and calculated in different ways to ascertain the molecule size, shape and bond characteristics (illus. 23). These measurements are only applicable to that particular molecule, with that particular molecular bond, although they differ from many observations of singular events in that the Raman spectrum can be recreated if necessary, using another molecule of the same compound. While conclusions in the form of broader chemical theories can be extrapolated from the Raman technique, the emphasis is on the specific and the numerical. The spectrogram images are converted to a set

21 Henry A. Rowland, *Photographic Map of the Normal Solar Spectrum, Made with the Concave Grating*, 2nd series, 1888.

opposite: 22–23 Dr. Michael J. Taylor, *Raman Spectra of Some Liquids*, made using Hilger equipment in the chemistry department, University of Auckland, 1968, glass plate.

MJT 31

RAMAN SPECTRA — P.C.L.

Spectrum of
Mercury
Arc

CHCl₃ 5
 15

CDCl₃ 5
 15

Impure
CDCl₃ 5
 15

Exposure time
in minutes

of numbers by various algorithms. The physical objects, the glass plates, are often subsequently discarded. Raman spectroscopy on glass plates, like those shown here, was adopted in the 1920s, using first solar light and later the mercury arc. The photographic emulsions were generally those adapted for astronomical photography, the so-called 'fast' emulsions. The technique has been used in chemistry, condensed matter physics and sometimes even in medicine and museum conservation throughout the twentieth century. Scientists made Raman spectrograms in analogue form (usually on glass plates) up to the 1970s. Now these images are made digitally.

The story of photography in observational sciences often resembles that of Raman spectroscopy. Photography, the eye analogy notwithstanding, does here what the eye cannot in allowing the collection of light over time. It produces images of spectra that are essentially not there. The extra lines are scatterings of light, leavings normally discarded to the side. They are nonetheless quantifiable, and correspond according to the laws of physics to the molecules that produce them. They are, for the lay person, impossible to read as any sort of image. Spectroscopists can 'read' these images, but the information is no use in pictorial form. It has to be converted into mathematics to generate useful data.

Processes that centred on measurement did not always have to dispense with the pictorial in this way. Photogrammetry is an excellent example of a photographic process that coincided in history with Raman spectroscopy, and that also relies on measurement. But photogrammetric images can contain visual information alongside the mathematical. Phototopography, iconometry, metrophotography and photographic surveying have all become loosely associated under the title photogrammetry, which began as a method for documenting buildings or landscapes by photographing them from carefully regulated points of view. In the 1850s and '60s, Albrecht Meydenbauer in Germany and Aimé Laussedat in France developed photogrammetric methods for the recording of buildings and landscapes respectively (illus. 24). In Berlin this led to the creation of the Königlich Preussische Messbildanstalt (the Royal Prussian Institute for Photogrammetry) where nearly 20,000 images still reside.[21] In France, Laussedat's *métrophotographie* had less tangible results, but his methods were adapted by Alphonse Bertillon to analyze crime scenes

24 Albrecht Meydenbauer, *Elisabethkirche in Marburg*, 1883, photogrammetric image, silver gelatin.

25 Alphonse Bertillon, *Photogrammetric Crime Scene*, 20 March 1913: 'Murder and break-in at Bezons' post-office'. The notes top-right give the height of the lens (1.5 metres), the focal length (15 metres), and the compass orientation of the optical axis (N.E. 45°). Albumen print mounted on card.

(illus. 25). Photogrammetry is in all respects as tricky as most other distance surveying. The successful measurement of the plates requires images with strict vertical orientation and at least one known control point. Although photogrammetric images look quite different – some, like Bertillon's, employ a visible grid, and others, like Meydenbauer's, do not – they all require this painstaking precision of camera placement and note-taking on the scene. In the schematic of Bertillion's photogrammetric crime scene, the placement of the camera is clearly marked within the grid. Without the orientation or control points, these images cannot be measured. Photography did not therefore obviate manual work on surveys, but it promised to shorten the time it took, and removed some of the danger inherent in clambering along building facades.

The popularity of photogrammetry in the nineteenth century was largely confined to the Continent. Many British authors were quite dismissive of the idea that such a survey of monuments could be useful or scientific, adjudging it 'more akin to an amusing game than to a useful art'.[22] But photogrammetry expanded slowly, first into archaeology, and then into aerial surveying, biometrics, geology and mechanical and civil engineering. The images, first as single photographs, then as stereo and sequential sets, are extensively used in archaeology. The extensive use of photogrammetry in archaeology in the twentieth century has even led to its introduction in underwater surveying of archaeological sites. The introduction of mapping in 3D by sequential photogrammetric imaging has made it an increasingly valuable tool. The Sesimbra Trial is part of a project to bring this sort of mapping photogrammetry not only to underwater archaeology, but to the general public. As part of the VENUS (Virtual ExploratioN of Underwater Sites) project, the Sesimbra Trial measures cargo from a presumed shipwreck near the mouth of the Sado River, off the coast of Portugal.[23] The three sequential images taken by Jean-Luc Verdier show industrial ceramic tiles photographed at a depth of approximately 56 metres. The resulting 3D map of the site allows archaeologists an overview that would be impossible in a dive situation (illus. 26).

Unlike the Raman spectrograms, photogrammetric photographs provide a picture we can recognise as a photograph. The ladder at the base of the church steps and the fish swimming through the Sesimbra images

26 Jean-Luc Verdier, *Sesimbra sea trial*, photogrammetric strip, excerpt of three images, 25 October 2007, made with a Nikon D200, 20mm lens, embedded in a housing Sea and Sea DX5 with two flashes Ikelite SB125 at a depth of 56 metres. In the framework of the VENUS Project, Mission in Sesimbra, Portugal.

are just the sort of accidental pictorial details lacking in Raman spectro-grams. Although Meydenbauer's Marburg church has an other-worldly flatness about the roof, it is still recognizable as a roof. The Raman images generate very specific information and not much of the accidental. Therefore, when the mathematical information is harvested and published, it is often the case that the physical photographs have little to offer, and most of them have been discarded. Measuring photographs that also offer accidental pictorial details are, on the other hand, more likely to survive in archives. Thus it is the case that the vestiges of the vast majority of these sorts of measurement photographs are only visible in the pages of professional science journals. The Meydenbauer archive and archives like that of the Cartes du Ciel are the exception.

Generating Observables

'Photography makes the invisible visible!' is the usual sort of headline we encounter when talking about photography and observation. This way of speaking lumps together very generally some of photography's most complex effects – effects that are quite widely varied in scope, scale and presentation. First is the registration of incidental, numerous and often minute details in objects visible to the human eye (illus. 27). There is also the effect of rendering the very small larger – for instance, photographs made under the microscope (illus. 28) – and rendering the very large smaller, for instance, making hand-sized images of swathes of the Milky Way (illus. 29). It might mean slowing action down by means of the stroboscope, as E. J. Marey, Eadweard Muybridge, Harold Edgerton and Ernst Mach did (illus. 30, 55). Or it might mean speeding up a process, like films of plant cycles on the Nature channel. If we refer back again to Talbot's assertion that the eye of the camera can see where the human eye sees nothing but darkness, one could say most photography relies at its very simplest on 'invisible', ultraviolet rays. The various functions listed above, however, are more than just the making of invisible things visible, they are entirely new methods of observing. There are two ways photography generates observable things: first by singling out a moment of

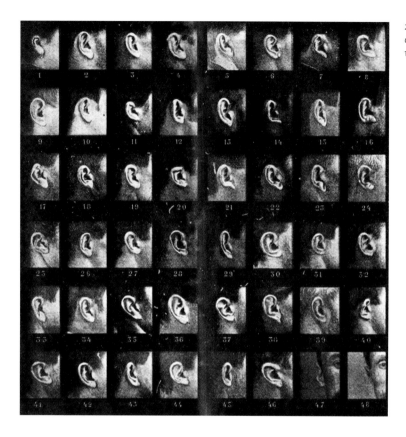

27 Photographer unknown, *Ears: Illustrating certain types of ears referred to in the text*, 1901, photomechanical reproduction.

time usually too small for human perception to register; second, gathering up light over a number of seconds, minutes, hours or even days and presenting it as one image. This last also includes the hybrid multiple-exposure – that is, short exposures made individually but then combined to create a new image.

The use of the strobe or spark, for instance, when applied to photography (it was used independently of photography for eye observations as well) is a powerful tool for the isolation of single elements in the stages of motion. The motion can refer to human bodies, projectiles, splashes, smoke or any number of ambulant objects. This high-speed photography, as it became known, differs greatly from human observations of the same activities. In physiology, the use of the stroboscopic, or graphic, method (as

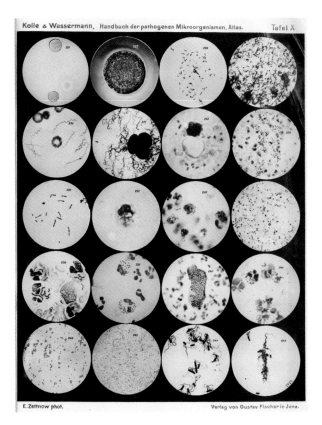

28 Emil Zettnow, *Microorganism Plate X*, c. 1902, silver gelatin.

29 Edward E. Barnard, *Nine selected areas of the Milky Way photographed on a small scale*, plate 51, 1927, albumen print.

Marey named it) broke human and animal motion down into finely distinguished moments (see illus. 64). It allowed gait analysis by disregarding the whole and concentrating on the pieces. The whole, in this case motion, could be recombined as a moving image, but the trend was there to see motion as a series of individual discrete movements strung together, rather than as a continuous whole. In the Raman method, or in Francis Galton's analytic photography, the process was one of collecting and combining rather than separating. Raman images combine photon activity over many hours, the Carte du Ciel negatives combine three different exposures and Francis Galton layered many negatives to achieve his composite human 'types' (illus. 31). These composite images belong in many ways to the tradition of the ideal scientific drawings of the eighteenth century.

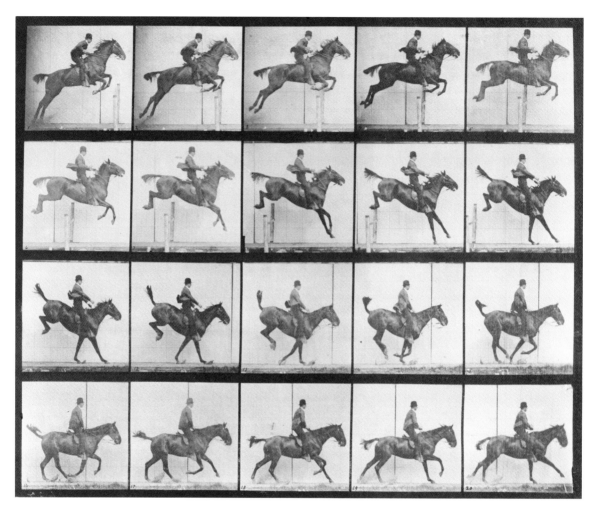

In the 1890s photographic observation was transformed. Although it had always revealed objects too small, too fast, too complex, too slow and too far away to be seen with the eye, the discoveries of x-rays and radiation broadened the scope of photographic observation and led to a great many photographic experiments, as we will see in the following chapter. It began with Wilhelm Röntgen's 1895 announcement on what we now call x-rays, which were long referred to as Röntgen Rays (illus. 32). Like the ultraviolet spectrum, these rays were invisible to the human eye, but worked, as light

30 Eadweard Muybridge, *Animal Locomotion*, 1887, collotype.

31 Francis Galton, *Specimens of Composite Portraiture*, c. 1883.

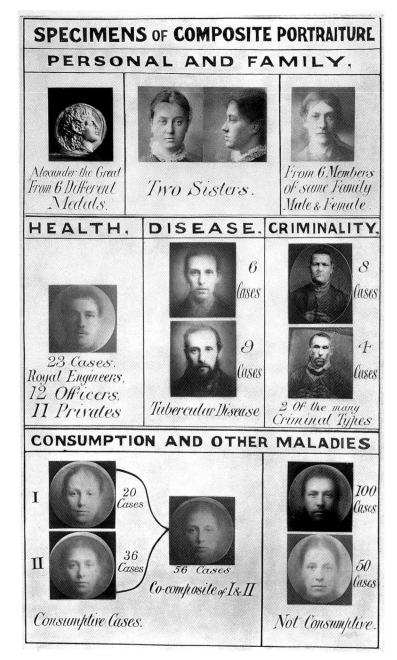

SPECIMENS OF COMPOSITE PORTRAITURE

PERSONAL AND FAMILY,

Alexander the Great From 6 Different Medals.

Two Sisters.

From 6 Members of same Family Male & Female.

HEALTH. DISEASE. CRIMINALITY,

23 Cases, Royal Engineers, 12 Officers, 11 Privates

6 Cases

9 Cases

Tubercular Disease

8 Cases

4 Cases

2 Of the many Criminal Types

CONSUMPTION AND OTHER MALADIES

I *20 Cases*

II *36 Cases*

56 Cases Co-composite of I & II

Consumptive Cases.

100 Cases

50 Cases

Not Consumptive.

overleaf:
(left) 32 Wilhelm Konrad Röntgen, *Magnetnadel in Metalldose* (Magnetic compass in metal tin), 1895, silver gelatin print.

(right) 33 Collection of Louis Westenra Sambon, *Victim of Elephantitus* [Elephantiasis], 1919, autochrome.

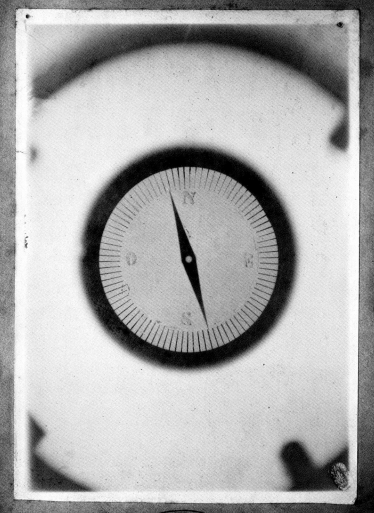

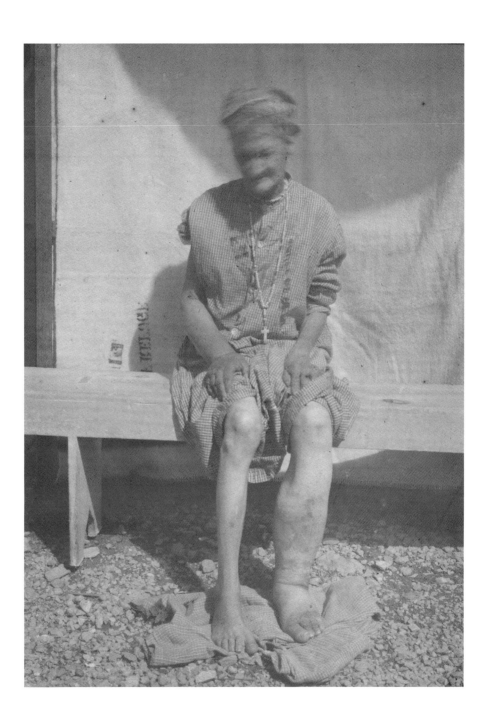

did, on the photographic emulsion. Again, unlike any part of the human anatomy x-ray photography allowed for a sort of observation heretofore unknown; penetrative observation. The sensational nature of the reception of x-rays can hardly be overstated. It was as if photography had been born again, more powerful and more omniscient than before. Images made with x-rays were published widely in the daily press as well as in photographic and specialist scientific journals.

Medical practitioners immediately began to test their usefulness for diagnostics and physicists began experiments searching for other 'invisible' but photogenic 'rays', all of which were soon gathered under the general title 'radiation'. Until this time, photography had not been overly successful as an observational method in the sciences of medicine and anatomy. It had been used with some success in the case of skin or deformative conditions, but photographing anatomical specimens successfully was difficult (illus. 33). This was in part due to the overall similar colouration of dead tissue, but also to the undifferentiated tissue abnormalities that occurred between one specimen and another. As teaching tools, photographs were much more vague than good anatomical drawings. x-ray photography soon changed all that. It took a leading diagnostic role in medicine, starting a century-long tradition of medical observation (illus. 34).

X-ray photography arrived at a time when the reliability of photography was acutely questioned in both scientific and popular cultures.[24] The rhetoric of replacing the error-ridden, limited, fatigable human eye with photography, which appeared to be as indiscriminate as it was infallible, was beginning to wear thin under the weight of incompetent portraitists and photographic confidence men (and women). Photographs of spirits and faked events, heavily retouched portraits and landscapes, all added to the notion that photography was a malleable medium, and malleable media are not the stuff of objective, passive observation. In the face of scepticism about the medium of photography, experiments on photographic emulsions were of crucial importance if scientists were to employ photography with authority. These sorts of experiments worked together with photographic observation to bolster the faltering reputation of photographs, establishing them as sufficiently scientific.

34 Josef Maria Eder and Edward Valenta, *Hand eines 4 jährigen Kindes* (Hand of 4-year-old child), 1896, photogravure from an x-ray, 19.9 x 8.2 cm, image on 48.8 x 34.1 cm, album page.

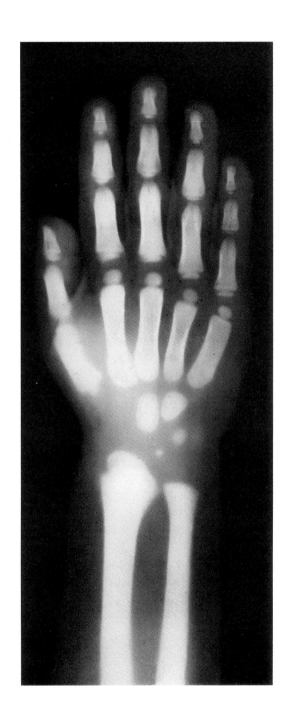

Photography and Experiment

Photography is not a group of processes; it is a science whose domain remains little explored and which offers the most pleasurable surprises to those who devote themselves to it.

Henry du Boistesselin, 1904.[1]

Experiments are not only counterpart to observation but have long been set in opposition to it. Experiments exist to test theories, sometimes theories that have emerged in the course of making observations. They often take place in labs, but not always. The outcome of an experiment is usually some sort of evidence – evidence used in argument for or against various theories. This being the case in so many situations, discussions about experiments usually contain discussions about evidence. One of the first questions to ask is: 'What makes the evidence reliable?'. If your evidence consists of a photograph, then the question might as well be, 'What makes photography reliable?'. This chapter, then, deals with the inner workings of what makes photography in experimental situations reliable, or for that matter, unreliable. One of the trickiest elements about the reliability of photography is the amount of control afforded to scientists who use it. For quite a long time it was unclear what exactly was going on in the photographic emulsion at the level of the photochemical reaction. The lack of this seemingly essential knowledge couldn't alone invalidate photography as a useful experimental instrument, or as a vehicle for evidence, but it did generate a particular sort of relationship between photographic experiment and experimental photography.

Like a canary in a coal mine, photography is often called on to do work in areas where human senses fail. Just as it expanded the field of observation into the realms of the near- or wholly invisible, photography expanded the field of experiment as well. When it was introduced it was immediately used by some physicists, like Jean Baptiste Biot in Paris, to broaden ongoing research on light by rendering previously unseen parts of the spectrum as fixed, visible entities. Photography added a not unknown but still seldom addressed chemical dimension to these studies. 'As far as physics is concerned', wrote Biot to Henry Talbot after receiving one of the first samples of photogenic drawing paper sent to France in February 1839, 'sensitive papers, like [Daguerre's] and yours, (which I will not delay in using as well), are instruments of the most useful sort.'[2] The light-sensitive papers also provided a whole new field in which new studies could be grounded. This was especially true of the subjects in which Biot was particularly interested, solar and electric radiation and the action of phosphorus.[3] Biot used Talbot's photogenic drawing paper to examine the chemical reactions of silver salts in certain wavelengths of light, having suspected early on that the chemical action was effected by only a portion of the spectrum, not the whole thing. His nineteen-year-old assistant at the time was none other than Edmond Becquerel, who would later become a specialist in daguerreotype spectra and phosphorescence and one of the co-founders of the Société Française de Photographie. The chemically active part of the spectrum, the actinic rays as Biot called them, busied untold numbers of physicists, chemists, astronomers and photographers throughout the nineteenth and twentieth centuries. To those who would dismiss photography as *merely* a detection device, it can only be pointed out that canaries too have their uses outside the field of mining instruments. Photography became many things: a field for experiment, a producer of didactic images used in the education of particular readerships and a unique sort of measuring device. Often a photograph has multiple functions in its lifetime. It might begin as a detection device in an experiment, be printed as an illustration and eventually be hung on the wall as art. Berenice Abbott used a strobe to photograph a bouncing golf ball every thirtieth of a second, illustrating the laws of mechanics. It was then used as the

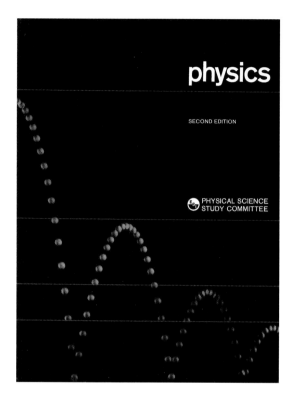

35 Berenice Abbott, front cover of textbook *Physics, The Principles of Mechanics*, c. 1965. This image was made by photographing a bouncing golf ball every thirtieth of a second by the stroboscopic method.

cover image for a physics textbook (illus. 35). Another of her images, a photogram made with her trademark Super Sight method, showing patterns of interference in water, was used as the back cover.[4] Her photographs of physical phenomena, along with those made by Harold Edgerton and others, were used throughout the 1960s by the Physical Science Study Committee, influencing a generation of American physics students. Both Abbott's and Edgerton's photographs are now collected as near-abstract masterpieces of modernist photography. Context is everything in the life of a photograph.

To approach the subject of photography and experiment, it is best to start with the traditional division of observation from experiment in the history of science. The two are sometimes divided along the lines of work in the lab versus work in the field, and sometimes use the notion (since the nineteenth century) that observation is passive, while experimentation

is active. Photography, however, is a hybrid activity, part observation, part experiment and part archiving. When we consider the role of photography in either experiment or observation, these two seemingly polar opposites begin to look remarkably similar, even sometimes indistinguishable. Although experiments themselves require an active intervention of some sort, the machines or instruments used in an experiment still need to be reliably passive or neutral in their work. In the 1840s photography was presented as the perfect and perfectly passive observer, and science reinforced the message long after daily use proved it to be quite the opposite. This rhetoric of passivity would have the artist rendered obsolete, the hand uninvolved, the imagination untapped.[5] It provided the perfect, and perfectly deceptive, platform for the use of photography as a scientific instrument in complex experimental situations. It was deceptive because it succeeded in 'black-boxing' photographic activity, denying the complexity of the relationship of photographic experiment to experimental photography.

Histories of scientific experiments do not usually include discussions about photography, any more than histories of photography include analyses of scientific experiments. The single exception is in cases where photography was turned on itself, probing its own light-sensitive activity, to find out exactly why the image that appeared on the emulsion looked the way it did.[6] At issue was control of the photochemical reaction. Control was essential if the results produced photographically were to be taken as believable evidence. Journals like *Photographic Engineering*, the *Journal of Imaging Science* and the *Journal of Photographic Science* were dedicated entirely to the chemistry and physics of emulsion science in the twentieth century. They were supplemented by numerous articles published in mainstream science and photography journals like the *British Journal of Photography*, the *Journal of Chemical Education* and *Advances in Physics*, to name but a few. The history of emulsion science remains, however, almost unknown outside a small circle of specialists. The subject of imaging science might sound dull, but much is at stake. Within the little-told tale of sensitivity data and characteristic curves exists a struggle over faith in the photographic image as an experimental instrument and, eventually, as evidence. At rare moments in history, photographic sensitometry

and emulsion studies emerge as the chief players in a drama. For a very short time, the work of chemists Ferdinand Hurter and Vero Driffield on the characteristic curves of photographic emulsions were much the talk of the photographic and scientific communities, thanks to P. H. Emerson's contentious and highly public lamentation of the impossibility of art photography in *Death of Naturalistic Photography*.[7] More often, emulsion studies are a part of a quieter story, creeping along behind the headlines of history, embellishing and sometimes altering it. A long history of photography and experiment would celebrate mathematicians, researchers, statisticians, and a contingent of mostly unknown chemical tinkerers along with rather better known inventors of this or that photographic improvement. What is written here is only a very small excursion into that history.[8]

Photography as Experimental Evidence

Sir John Herschel first demonstrated the practicality of photography as an experimental tool, claiming in March 1839 that he had isolated a filter that increased the action of light on a silver emulsion.[9] The story of Herschel's involvement in early photography and his experimental goal of producing not only new photographic processes but full colour photography have been well documented.[10] The influence of his work on the broader scene of experimental photography has not. Herschel's investigations, taken as a whole, and not just the one instance of March 1839, show a clear link between the development of new photographic processes and experiments conducted (in this case on light) using photography. This is not to say that photographic experiment and experimental photography must always go hand in hand, but that they often do. For our purposes these cases are the most interesting because they are often the cases where the role of photography in the experimental setup is particularly important. In his unpublished paper of March 1839, Herschel described the curious results of his experiments with a so-called 'exulting glass', a piece of coloured glass under which photographic drawing paper exposed more quickly. Herschel assumed that the glass filtered the light

in a way that concentrated the photographic effect. He found that his hypothesis was mistaken, and the accelerated exposure was produced not by the action of one part of the spectrum over another but instead by a thermal reaction. One glass heated the emulsion more, causing it to expose faster. This form of baking an emulsion would be one of the tricks used by astronomers in the 1880s for creating films sensitive enough to register the light of distant stars. Although Herschel's conjecture about the exulting glass was wrong, he still contributed to photography's

36 John Frederick William Herschel, manuscript page with photographic specimen, from *Note on the Art of Photography or the Application of the Chemical Rays of Light to the Purposes of Pictorial Representation*, read before the Royal Society, 14 March 1839.

reputation as a bearer of evidence by attaching one of his photographs to the paper. It was never published, but on 14 March 1839 this page would have been viewed at a meeting of the Royal Society in London (illus. 36). The piece of photographic paper stood in for the usual method of demonstration, where a scientist would recreate an experiment for others to corroborate. Photography served the purpose here equally well, if not better, as no group of scientists would have been able to witness in person the slow darkening that had occurred over many hours.

Since 1839, photographs have often served in this capacity as experimental evidence. They do this in several guises. The most common of these is the 'iconic image', where a single photograph is used to represent a series of experimental results. Key images have often been plucked from their companions to serve as carriers of the great weight of evidence produced in reality by extensive runs of experiments and multitudes of experimental image results.[11] This is why we have become so familiar with Muybridge's galloping horse, Edgerton's splash of milk, Rosalind Franklin's x-ray diffraction pattern image of DNA and Étienne Jules Marey's walking man (see illus. 64). The use of single images as representations of the whole explains how so many photographic images became icons of one or the other areas of science. The majority of experimental photographs have been lost or forgotten in overwhelming numbers, and very few complete sets of experimental results remain. One of the exceptions is the work of Henri Becquerel.

One February morning in 1896, Antoine Henri Becquerel, Professor of Physics as his father and grandfather had been before him, conducted an experiment in his laboratory at the Jardin des Plantes in Paris. He carefully wrapped a Lumière Étiquette Bleue glass plate in black paper.[12] He then placed on top of it a crystal of double sulphate of uranium and potassium. It was a crystal inherited from his father Alexandre Edmond, the same Edmond who had assisted Jean Baptiste Biot in 1839. Henri Becquerel then put the plate and crystal in the sun for several hours. When he eventually unwrapped, developed and fixed the plate, the crystal had left a perceptible silhouette. It was formed, he concluded, by fluorescence emitted by the crystal after exposure to sunlight. He would soon find that he was mistaken. Photographic plates were also

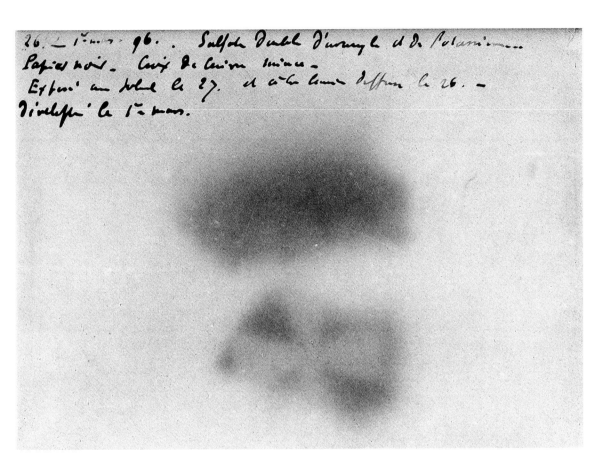

26. — 1ᵉʳ mars. 96. . *[handwritten notes in French, partly illegible]*

37 Henri Becquerel, *Image of a Cross produced by Radioactivity*, February 1896. Photolithograph.

exposed 'spontaneously' even in the dark, in the absence of fluorescence (illus. 37). This was the beginning of several years in which photography was critical to the investigation of radioactivity, and by association, atomic physics. Becquerel's was also one of the early barrage of experiments in which photography and film played a leading role.

Becquerel's use of photography, and indeed Herschel's as well, are examples of the dual nature of photography's relationship to experiment. Becquerel's experiment was designed not only to investigate the rays supposedly emitted along with fluorescent light, it was also an experiment designed to investigate the photographic emulsion itself. Becquerel wanted to know two things: first, was the crystal of double sulphate of

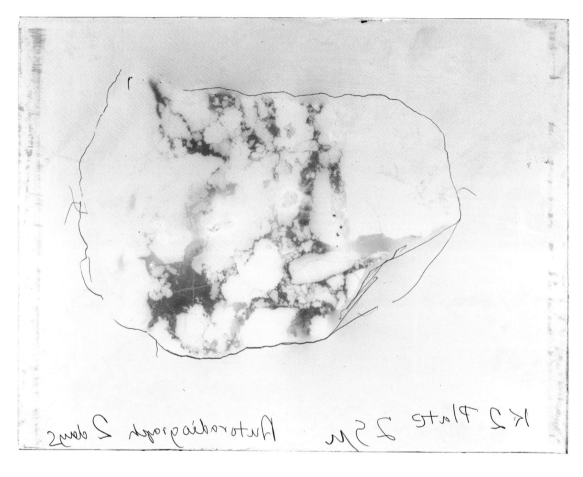

38 William Crookes, *K2 Plate autoradio-graph 2 days* (written on the reverse), c. 1900, silver gelatin glass plate negative made for the paper 'Radio-activity of Uranium', read before the Royal Society, 10 May 1900.

uranium and potassium emitting invisible rays along with visible fluorescence that could pass through the black paper wrapping covering the photographic plate? And second, was the photographic emulsion stimulated by rays emitted along with fluorescence? The answer was a resounding yes in response to both questions. Becquerel went on to make his own collodion and albumen emulsions, testing them apparently against the Lumière plates but always returning to his trusty Étiquette Bleue.

Becquerel's work, and indeed much of the experimental work that took place using photography in the 1890s, was based on the astonishing discovery and proliferation of experiments on x-rays. He and others like

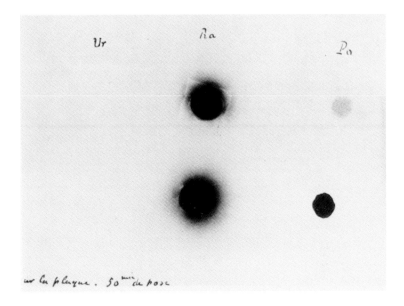

him opened up numerous new avenues of physics research, especially in the direction of atomic studies. Only part of these research programs called for photography, the others relied on magnetic instruments and electroscopes (devices for measuring positive and negative electrical charges). What is interesting about photography's role is the variability of uses to which it was put. In some cases, like that of William Crookes, the photographic plate detected radiant sources (illus. 38).[13] Becquerel used photography for this too, measuring the penetrability of rays from different radioactive substances through various solid barriers (illus. 39). This use of photographic emulsions to detect radioactivity is the precursor to the use of photographic films, installed in small badges, to detect overexposure to sources of radiation in government nuclear laboratories or in the medical industry. In the sensing of radiation, photography was low-tech but effective, so effective that the large film companies developed and marketed film badges, and do so today. The simple fact that photography had been proven to detect Röntgen's rays was enough to bolster the 'discovery' that photographic plates detected other equally invisible rays. But this doesn't entirely explain the relevance of photography to radiation research, or the effect radiation research had on photography.

In the pages of the popular journal *Le Radium*, photography was used to illustrate the new research to the wider scientific public. Illustrating this branch of science required more of photography than had heretofore been asked (illus. 40). The journal itself published a mixture of articles investigating the phenomenon of radiation and articles investigating the photographic emulsion. Researchers who wanted to work in the field of radiation studies were also very likely to investigate photography. Very often, these photographic methods, as the name implies, are more than just a casual use of photography. They are programmes of experiment in which photography is an integral part. Photographic methods have been used to register spirits, atoms,

40 Pages of *Le Radium*, 'Action photographique des rayons du radium' (Photographic action of the rays of radium), 1904.

opposite: 41 Henri Becquerel, *Isolation of gamma radiation in Radium*, after Paul Villard, 1903, gelatin silver print.

radiation and a whole host of things real and imagined. The success or failure of a method lies in its transparency, its ability to be repeated by other scientists and the replicability of its results. The photographic method for investigating radiation, as opposed to the electroscopic method, incorporated not only detection but at the same time the representation of radioactivity. In this way, photographs could be used both as evidence of the physical characteristics of the radiation and as illustration of it, and they often were. Henri Becquerel, who, like his father, had worked his whole life with photography, created a very distinctive photographic method and used it in collaboration with a number of Parisian scientists, among them Paul Villard, Marie Curie and Henri-Alexandre Deslandres. He developed a special apparatus to show the various parts of radioactive 'rays'; alpha, beta and gamma (illus. 41). In Becquerel's photographic method, it was important not only to show his photographic evidence in public, but to create images

42 Henri Becquerel, *Zeeman curve*, 1899, sent to Woldemar Voigt in a letter, silver gelatin print. One of the advantages of photographs made on paper is their portability. Many such experimental results were simply sent through the post, either on loan or as a gift.

that could illustrate the physical qualities of radioactivity. In this particular image, he illustrated all three types of rays, and their various traits. The curved alpha radiation differs from the magnetically deviable beta radiation, which is distinct from the undeviable gamma ray. He eventually published 60 laboriously photolithographed images to illustrate his research and to validate his photographic method.[14] It is only as a result of this publication that the complete set of experimental photographs survives. Becquerel carried his photographic method on into the field of magneto-optics, studying curiosities like the Zeeman effect, the breaking of a spectral line by a magnetic field (illus. 42). For a while in the early twentieth century, photographic methods of studying radiation fell out of favour. Then, in 1911, C. T. Wilson built the first cloud chamber, and photography was put to use again, capturing atomic particles as they became visible in the condensed air.

Experimental Control

Many of these carefully contrived images of Becquerel's succeed in proving the validity of his evidence through the demonstration of control over the photographic medium. Control of the photochemical reaction has been an issue since it was discovered. Perhaps the best example of the mixed signals photography sends can be seen in Arago's early experiment (perhaps 1821, perhaps earlier) with silver nitrate and the interference of polarized light. Arago began by exposing silver nitrate salts to the spectrum cast by his spectroscope (illus. 43). After examining the spectrum, and the stripes formed in the silver nitrate, he claimed that the stripes matched what his eye saw in the diffraction experiment, and this was reason enough to believe that the result recorded the 'truth' of interference. (This is a simple repetition of the eye analogy explained in the Introduction.) He said this *even though* he remarked in the following sentences how the chemical action of the light did not match human perception. Humans see the 'strongest', that is, the brightest, part of the spectrum near the yellow bands. Silver salts give us quite a different perception of light 'strength' by 'seeing' the brightest part of the spectrum, that is,

recording most quickly or darkly, in the blue/violet region and beyond.[15] It is a common reaction to photographs. We believe them even when the differences between various types of emulsions make it obvious that photography doesn't act like our vision, but is susceptible to other physical rules. Testament to the power of this intuition is the slight feeling of vertigo produced by looking at side-by-side images of a bouquet made on an isochromatic plate and an orthochromatic plate (illus. 44).

Arago's text contained conflicting sentiments similar to those of later scientists regarding their work with photography. The lingering suspicion that photography wasn't telling them the whole truth led many scientists to ascertain just how far photography imitated the world. They did not blindly trust the photograph to give them results that were unquestionable, invariable and closed to interpretation. They understood just what tricky substances silver salts could be, and accorded them appropriate respect, even while continuing to use them for experiments. Although there was faith in the analogy of photography with human vision, scientists trusted more in their capacity to interpret photography, and their ability

43 François Arago, *Vue perspective du photomètre de M. Arago*, c. 1821. At M, the spectrum would fall on a strip of paper coated with silver salts and dried. These experiments, like many others, were not fixed and would be obliterated by further exposure to light.

44 F. Monpillard, phototypes exhibiting the differences in tonal scale given by an 'ordinary' isochromatic plate on the left and an orthochromatic plate, using a yellow filter, on the right. Reproduced in *Le Radium* (1905).

to control it, than they are often given credit for. They even worked closely with photographic manufacturers, tinkering with the emulsions and running experiments, much as Biot did with Talbot's first papers.

Auguste and Louis Lumière, the brothers most famous for their work on motion pictures, were just such manufacturers. They were interested

and involved in the radiation experiments, and indeed all photographic experiments, going on in Paris at the time. It stands to reason, since the majority of these were made on Lumière glass plates, usually the lauded Étiquette Bleue, or as they were marketed in English, Lumière Blue Label dry plates. Unlike the dry collodion Abney endeavoured to master in 1874, these plates used gelatin to bind the emulsion to the glass. Since gelatin can dry and become porous again when re-immersed in a liquid developer, it was the perfect medium for a truly dry process. It was hardly an immediate success, however. Although dry gelatin plates existed from the early 1870s (Abney took some to the transit) they were not widely adopted by professional photographers until the mid-1880s.[16] In addition to publishing articles in *Le Radium*, the Lumière brothers conducted tests on their emulsions and occasionally presented their findings at weekly meetings of the Academie des Sciences in Paris. They were interested in the sensitivity differences in extreme conditions like cold and heat, but also in the various developers that could be used to enhance the already speedy plates.

Why exactly were these sorts of collaborations between industry and scientists of such great benefit? For the industry, of course, research on new discoveries was nearly always worth the expense, even though day to day reports show research labs like Kodak's losing thousands of dollars in specialized film development. For the scientists, it was a chance to enhance their understanding of the instrument they were introducing into their laboratories or observatories. Only in the early twentieth century were reliable film speeds established. In order to trust that the photographs they were making were going to provide them with a certain sort of evidence, scientists needed to be able to exert control over the photographic process. They needed to demonstrate their awareness of the most intimate workings of photographic sensitivity, and their control of it, right down to designing the emulsion.

The exertion of control over the photographic emulsion, and consequently over the photochemical reaction, led eventually to the designer emulsion – that is, an emulsion designed to react to a very narrowly defined stimulant. Most of the histories of photographic emulsion development have been centred around the triumphalist account of the

achievement of 'speed'. But in experiments that need highly tuned instruments, faster is not necessarily better. 'Speed' or sensitivity, moreover, was a highly unreliable measure. In the decade leading up to the First World War, speedy emulsions gave variable results, partly because their sensitivity faded if they were stored for any length of time before use, and partly because the latent image faded if any length of time passed between exposure and development. This was a problem that was especially disturbing for photographers of particle physics, who sent plates up in balloons or aircraft to increase the chance of capturing cosmic radiation at high altitudes. For these experiments highly specific emulsions were better than faster ones. Specific emulsions have been created to do many different things, even – counterintuitively – to be insensitive to visible light. They might be calibrated to a specific range of solar light, excluding some wavelengths while emphasizing others. They could even be made less sensitive to gamma radiation. Like all photography, these special films can be used to observe discrete moments or to compile and combine radiation over a long period of time. They differ insofar as their purpose is not only to gather information but to filter out extraneous data.

Colour was of course one of the first goals of those who would create designer emulsions. It took longer than most had imagined, and even when it was achieved, the end result was far from ideal. Through the history of photography there runs a dual meaning in the phrase 'colour-sensitive' emulsion, and the two meanings are often confused. The first way of using the phrase refers to a black and white emulsion that is fully sensitive to all ranges of the spectrum. Within this category there are three types of emulsion. Isochromatic films are blue/violet sensitive, like daguerreotypes or calotypes. Orthochromatic films, such as those developed by Hermann Wilhelm Vogel in the 1870s, extended the sensitivity well into the green part of the spectrum, and were long used in industrial printing, mammography and radiography. Panchromatic film is sensitive, as the prefix indicates, to all wavelengths, including the problematic red end of the spectrum. All of these emulsions were developed before 1900, and perfected well into the twentieth century. Colour film, the second way of speaking about colour-sensitive emulsions, indicates emulsions that react to and record the colours in their natural order. (Films named

2879—1905.

45 Frederic Eugene Ives, *Geological diagram by Colin Campbell Cooper*, 1905, additive three-colour print.

'chrome', as in Kodachrome, indicate a direct positive film. Those that end in 'colour' are negative films.) They proved to be so complicated that they were rarely if ever used in scientific experiments. Only with the advent of digital imaging has colour made significant inroads into scientific imaging.

In the late nineteenth century painters and illustrators were still engaged to make most colour scientific images (illus. 45), especially those shown in print. It was only with Frederick Ives's additive three-colour process that this began to change. By 1892 Ives had worked out this method, which could be used for printing as well as for making photographs. The object, in this case a coloured geological diagram by the artist Colin Campbell Cooper, could be photographed three times, in black and white, through three filters (red, green and blue). These negatives were then printed successively with their corresponding inks and black to form a full-colour print. Ives also made full-colour images by printing the negatives on glass plates, then placing them in his Chromoscope, a viewing device which filtered in light corresponding to the red, green and blue negatives. They then took on the appearance of full-colour images. Although this method was too slow for photographing objects that moved, various forms of it have been adapted for use in microphotography and astronomical imaging. Daniel Kalman and his lab group made the cover illustration of a mammalian cell infected with vaccinia virus in the same way. In this case, though, the colours were assigned not to replicate 'reality' but to isolate areas of research. Reagents that recognize the viral factories, actin (green) and the host kinase (red), each labelled with a different fluorophore, stained the cell. This made it possible to make three black and white images, each with a different filter set isolating the particular fluorophore. The three photographs were recombined, assigned colours and designed for publication by an artist.[17] Many astronomical images follow the same system, recording three or more 'black and white' images that represent different data: either wavelengths of light, or different light intensities, or different types of radiations (radio, light or x-ray). Colours are assigned either to correspond to the data or to correspond to different geographical areas of the system (illus. 46). This differs from so called false- or pseudocolour, where only one

47 Andrew Davidhazy, Tape-dispenser
as seen in colour when placed between
polarizers, 2005.

opposite: 46 Hubble space telescope:
'Hubble's sharpest view of the Orion
nebula'. Taken by the Advanced Camera
for Surveys.

exposure would be necessary.[18] In false colours, greyscales are often
absent, giving the image a flatter look, like the Magnetic Resonance
Imaging (MRI) images used in medical diagnostics.

Colour in science is often a diagnostic tool, effectively separating
out one area from another for research purposes. It hasn't, however
gone ahead without controversy. Analogies between astronomical images
and master paintings have brought the process of designing digital
images to the fore.[19] The problem is that colour is so subjective. What is
the 'real' colour of stresses in something manufactured (illus. 47)? Colour
photographs of this sort are dependent on the light source as well as the
type of photography for their colour. Polarized light thrown on everyday
manufactured items reveals stresses where the material, in this case

plastic, has been bent to its purpose. For analysing the stability of manufactured metals, this sort of photography can reveal areas of weakness, as well as enabling the measurement of the exact values if the photographs are taken in colour under a monochromatic light source.[20] Images that are created from data, like the LANDSAT images, are given their colour in the processing phase, often with the aid of a software package (see illus. 50–51). Each scientist, upon receiving the data, can apply the software package in slightly different ways. Filtering plays a large role in the creation of colour images, and it is the hallmark of designer emulsions.

One of the most interesting and perhaps telling examples of designer emulsions was the creation of special emulsions to further research in atomic physics. These became known as nuclear emulsions through the work of Cecil F. Powell, winner of the 1950 Nobel Prize in physics for his discoveries made using nuclear emulsions and his photographic method. After Becquerel's work on radioactivity, J. J. Thompson proved the particles in radioactivity to be charged particles and photographic methods were put to the side in favour of electroscopic measurements of these charged particles. In the teens and '20s of the twentieth century, though, there followed an intense period of the application of photography to recording the tracks of alpha particles and artificially accelerated protons. C. T. Wilson, S. Kinoshita, H. Ikeuti, Marietta Blau, H. P. Walmsley and W. Makower were, among others, authors of images of these sub-atomic particles. In the early phase, they adopted commercial films for their purposes: Agfa's K-plate, Ilford's 'Process' and 'Imperial Process' plates and Wratten's 'Ordinary' plates. Many of these plates were bathed in a solution of pinakryptol yellow to improve their sensitivity, but the effect was short lived and gave less than reliable results. Part of the problem with commercial plates was their thinness. Particles of course travel in a multitude of directions and were less amenable to the sorts of controls Becquerel had exercised over his radiation. Thicker emulsions were needed. It was also a problem that the emulsions were so unstable over time, because many of these tracks were taken from cosmic radiation, and naturally, the higher the emulsion was set out, and the longer it stayed in position, the more chance it had of capturing a track. Some exposures for cosmic radiation measure in the hundreds of hours. With all of these experiments,

the photograph was acting as a trap for randomly encountered particles and a filter of unwanted exposure (like visible light). The particles might be travelling directly perpendicular to the plate, and leave only a speck, indistinguishable from a silver grain, or they might travel at an optimal small angle through the emulsions leaving a longer trail. Normal commercial plates were never going to answer for these experiments.[21]

In 1945 the Photographic Emulsion Panel was established in England with the express purpose of creating nuclear emulsions.[22] Far from being atypical, the development of the nuclear emulsions, while better documented than many other science-industry collaborations, was a wholly typical activity in a time when scientists increasingly exercised control over the photographic image. Control in this case comprised a response to three specific needs: the reduction of grain size, the increase of sensitivity to electron activity and the reduction of fogging. The problem was that ambient light fogged the film base, while the presence of gamma radiation fogged the electron tracks. This was especially so with the Ilford 'Process' and 'Imperial Process' emulsions. The new emulsion was supposed to (and within a year did) act as a filter for both light and gamma radiation.

At this point it is important to take a short digression into the theory of the photographic process as regards silver halide emulsions. The creation of the latent image relies on various chemical, and in turn physical, reactions that are started by the stimulation of small crystals of silver halide by light. These silver halides (a mixture of both silver bromide and silver iodide) are physically modified by light or other radiant sources passing through a gelatin emulsion. One of the more intense areas of study in the 1940s, '50s and '60s was the exact nature of this physical change in the lattice structure that makes up latent images. Much of the research lies at the fringes of quantum physics in the growing field of theoretical chemistry. This silver halide is then 'developed' by putting it in a reducing solution, where the affected grains are turned into metallic silver. In order to improve the quality of emulsions for registering tracks of charged particles, the physical and chemical properties of photographic emulsions had to be optimized for the specific purpose at hand.

As usual, there was much competition between the largest photographic companies for the most successful result. Ilford produced its

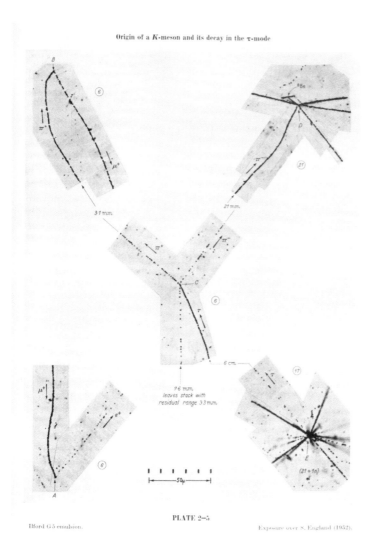

Origin of a *K*-meson and its decay in the τ-mode

PLATE 2–5

Ilford G5 emulsion.

Exposure over S. England (1952).

48 C. F. Powell et al., *Origin of a K-meson and its decay in the τ-mode*, plate 2-5, 1952, photomechanical reproduction.

solution in the form of emulsions of four different grain sizes (A, B, C and D), that could be combined with three sensitivities, 1, 2 and 3, increasing the sensitivity by increasing the ratio of silver bromide to gelatin.[23] Kodak followed in 1948, producing their NT4 emulsion, and Ilford again trumped this in the same year with the G5, several months after Kodak's announcement. So went the race for nuclear emulsion supremacy.

49 C. F. Powell et al., *Contact print of an emulsion sheet exposed on a BOAC Comet aircraft*, 1958, photomechanical reproduction. This print, from one of the central emulsions in a stack, shows seven unrelated cascades, each marked by two arrows.

But control doesn't just apply to the actual creation of the emulsions themselves, although this is important. Control is arrived at in the way in which scientists use the emulsions they have. In the case of nuclear emulsions, they were not only used individually on glass plates, but also multiply. This was done either by placing two plates together with the emulsions facing each other, or by stripping the emulsions from the plates, packing them together in a block. This block was then exposed to an x-ray beam, or flown to high altitudes to capture cosmic radiation. Each layer was then then stripped off and replaced on plates for development and printing. The 'Origin of a κ-meson and its Decay in the τ–mode' is a print derived from just such a process (illus. 48). Its emulsion block consisted of 46 Ilford G5 emulsion layers, each 15 cm x 15 cm. The subsequent print of the reconstituted tracks, reproduced in Powell, shows just how complex the process was. It had a labelling mistake, acknowledged in the text, that should have had the cluster of events seen at the top right actually attached to the track passing downwards – in this image labelled as leaving the stack.[24] The difficulty lay not only in spotting these minute tracks in the developed plates, but in distinguishing them from silver

grains or specks of dust, the so-called 'artifacts' of the photographic process (illus. 49). The contact print of a sheet of emulsion taken after 600 hours aboard a BOAC Comet jet shows just how difficult it might be to find the tracks. It was a job of many painstaking hours, performed mostly by women. This particular sheet comes from the middle of a stack, and shows numerous cascades, one unusually strong one at C5. As with the Carte du Ciel image shown in chapter One, it is always important to eliminate random specks that are not experimental or observational results. The recognition of instrumental artifacts is crucial to full control of the experimental emulsion. When this is not achieved, as in the case of the Venus transits, the photographs produce no (or worse misleading) results.

Today, nuclear emulsions are one of the few special emulsions still manufactured by Ilford, in the G5, K and L4 varieties, for use in particle physics. Not much has changed from the mid-twentieth century to the beginning of the twenty-first. Ilford's fact sheet on nuclear emulsions warns against excessive storage, radiation exposure and heat and light from the blue spectrum. It still cites articles from the 1950s as authoritative guides to the creation and processing of nuclear emulsions.[25]

Experimental emulsions like these nuclear emulsions epitomize the symbiotic relationship of photography and science in the twentieth century. Each small step in building an experiment involving photography required an equally small step in forming and moulding the photographic emulsion. The more controlled and predictable the emulsions became, the more reliable their evidence. As photographic evidence gained reliability in one photographic method, it was more likely to be used by another scientist in another method. The cycle would then begin again. In spite of the many dead ends, contentious arguments and outright failures of photography to provide adequate images, this relationship between photography and science has never been seriously challenged.

three
Photography and the Archive

> The Cartographers Guilds struck a Map of the Empire whose size was that of the Empire, and which coincided point for point with it.
>
> Jorge Luis Borges[1]

In the first three decades of the twentieth century a photographic archive was compiled in France. This archive, amassing 72,000 autochromes, 4,000 stereographs and nearly 183,000 metres of black and white silent film, among other things, was the brainchild of Parisian banker Albert Kahn.[2] The Archives de la Planète (Archive of the Planet), as it came to be known, was intended to document all aspects of human life, ostensibly to preserve peace and generate understanding between nations.[3] Kahn's was hardly the only attempt to create a comprehensive photographic archive at the time. In 1897 Sir Benjamin Stone had formed the United Kingdom's National Photographic Record Association to 'record for the future the antiquities, ancient buildings, folk customs, and other "survivals" of historical interest, forming a national memory bank'.[4] This urge to create the comprehensive archive in photographs goes back at least to the 1870s, perhaps earlier. Already in 1858, Oliver Wendell Holmes had called for a stereographic library where visitors could see 'any object, natural or artificial', and the United States Geological Survey was established in 1879 to collect and create an archive of the American landscape (illus. 78).[5] This 'collect everything' mentality differs from earlier attempts to organize scientific knowledge.

In the century and a half prior to the invention of photography, scientific knowledge was thought to be best organized by taxonomy, that

is, classification. Carl Linnaeus succeeded in revolutionizing botany in the eighteenth century with just such a system, likening plants to animals in their physical, especially their reproductive, characteristics. Type specimens were chosen as guides to the classification of plants, preserved lovingly in herbaria for consultation.[6] In the latter half of the nineteenth and through the twentieth centuries there emerged the impulse to store objects in great masses, not exactly without organization, but using more pictorial and less linguistic apparatus. Photographic archives are almost exclusively this second sort of archive. Such archives were of course arranged according to some sort of classification, but the difference was that this classification system could be changed and the photographs rearranged under a different system according to the purpose at hand. Photography and film did not drive this change, but they were caught up in it. Although both methods of archiving propose a way of ordering masses of knowledge for scientific purposes, there is a subtle but real difference in their respective trajectories of use. Taxonomies define what belongs where. Ideal taxonomies supply a sufficiently general system into which all new finds can be ordered as they appear on the horizon. Creating an archive with rigorous taxonomic constraints rests on the assumption that we know what important questions to ask of that archive. In contrast, the photographic archive of the latter type (mass collections), especially one that endeavours to do something like map world geographies, knowledge or history, or encompass human memory, assumes that we don't yet know what the questions are. The impulse behind creating photographic archives for science is to gather up an infinite number of details and save as many of them as possible for the development of unforeseen and unforeseeable investigation. It accompanied the move away from 'ideal' typological specimens and toward serial collection (see illus. 9 and 69). It would be claiming too much to say that the invention of photography instigated this second way of collecting and organizing archives of knowledge. But photography was deeply involved because of its singular trait of obtaining unlooked-for and seemingly trivial detail. When the questions of a future scientific endeavour are unknown, trivial details might just be the key to inquiries of the future, and by this reasoning they should therefore be preserved in their multitudes.

Notably parodied by Borges and Lewis Carroll, numerous failures of this sort of comprehensive mapping project have had little effect in stifling the impulse.[7] Each new technology, first photography, then film, then the Web, has been greeted as the potential saviour of the idea of the comprehensive knowledge map – a map that contains all the details not only of the knowledge of the present but of the knowledge of the future. The LANDSAT Project testifies to the health of such endeavours today. Begun in 1972 by NASA, and controlled jointly by the United States Geological Survey, the LANDSAT Project photographs overlapping swathes of land, knitting them together to form a continuous map of the globe from space (illus. 50). Not only does it claim to comprehensively cover geographical areas at a specific time and date, but it re-photographs those same areas again and again, re-mapping them over decades or years. Its job is to create an archive that not only identifies the state of a landscape at one particular point in time, but that provides an archive of landscape change over time by repeating its photography of the same coordinates *ad infinitum* (illus. 51).

The LANDSAT Project is perhaps the perfect foil against which we may measure the ambitions of scientific archives that employ photography. Just how does photography in scientific archives work? What are its expected roles, its weaknesses and strengths, its limitations? The stakes are quite high, after all, with a scientific archive. It brings together the knowledge that is collected and protected (for better or worse) to facilitate learning, to control the boundaries of history, to shape and colour a particular view of the world. Photographic archives have been conceived not only to tell concrete narratives like histories of art or political regimes or geographical areas, but sometimes to explain such intangibles as the science of civilization and the function of memory. There are often political and deeply divisive questions about who controls archives and who has access to them. What concerns us here, however, is not politics but the specific relationship of photography, science and archive and the special sort of authority given to images produced as a result of this relationship.

In the preceding two chapters, we have seen two aspects of photographic authority. The first is the special relationship forged, by virtue of its mechanical or chemical nature, between photography and certain scientific

50–51 LANDSAT images of Finger Lakes area, New York. 25 April 2003 (left) and 22 August 2000 (right).

values like passivity and objectivity. The adjective 'photographic' sometimes replaces 'scientific' when this view is invoked, and the photographic archives created according to this model are 'scientific' archives because they are 'photographic' archives. In the second aspect, the photographic process is one that requires an imposition of sometimes greater, sometimes lesser, controls. Imposing strict protocols either on the production of photographs or on the collection of them generates a level of sytematization in photographic archives. Although not all systems are scientific in character, in the photographic archive they are often used to exert controls on photography, tailoring it to a specific use. In this way they are not dissimilar to designed emulsions, tailored for a specific purpose. The method of photography is in this case subject to scientific rigour, and the result is, or should be, scientific. As you will have noticed, these two aspects lead to two quite different notions of photography: the first, that photography is inherently scientific and the mere use of it renders any project scientific; the second,

that photography is a subjective imaging device but one that can be controlled by stringent scientific method, which then renders the project scientific. The same end, the establishment of an archive as 'scientific', is reached but through widely different approaches to photography. These two aspects appear again and again in discussions that can be essentially distilled down to the question, 'what is photography good for?'. They are also essential to understanding the formation of photographic archives in the context of science.

In this chapter we will look at two specific traits of photographic archives that help to explain how these two notions of photography are implemented in real archives. The first section treats the base unit of the archive, the photographs. The second is the way in which knowledge is generated from photographic archives, that is, the epistemology of scientific photographic archives.

The Photographic Record

The cornerstone of every photographic archive, regardless of its origins and purpose, is the photographic record, valued for its objectivity, its ease of storage, its suitability for reproduction and its ability to endure.[8] Fixing an image renders the human observer's memory unnecessary, replacing it with a national or international 'memory bank', as Sir Benjamin Stone put it. Through the course of years a fixed image can be viewed repeatedly. The creation of fixed and enduring images allows scientists and institutions to form networks that are crucial to the operation of modern science. This is exactly the way the astrographic catalogue of the Carte du Ciel functions. Different observatories geographically distant from one another can share images of quadrants of the sky. Equally, astronomers now can use the information gathered by astronomers of the late nineteenth century (see illus. 16). A fixed image of *Helminthocladia Griffithsiana* can be compared to other types of algae or other pieces of the same algae. It can be folded up in a letter and sent to some part of the world where similar plants might exist, or it can be posted on the Internet for comparison and analysis (illus. 52).

So what makes archiving photographs of specimens different from archiving the actual specimens? Cyanotypes like that of Anna Atkins were of dubious botanical worth, but they were excellent harbingers of photographic archiving. Atkins's *British Algae*, published serially between 1843 and 1853, brought together specimens of different size and thickness, regularizing them into a book format for comparison and for flat storage. These traits of photography, its flatness, its ability to render objects of drastically different size next to one another and its multiplicity, all make storing and archiving photographs different from storing and archiving objects. Enlarging and reducing the size of objects in photographs is particularly helpful for archiving purposes. In this photograph of the Hercules Cluster, enlarged ten times from the original size on the plate, shown in the upper right corner, the group of more than 100,000 stars made just a small dot on the original glass plate (illus. 53). Photographs also promised to be more robust than some specimens, even though this was not at all the reality. It is one of the ironies of photography's use in

Helminthocladia Griffithsiana.

53 Paul and Prosper Henry, *The Hercules Cluster*, original and ten times enlarged, albumen print. The upper-right corner shows how small the target was recorded on the original plate.

archives that even in the face of practical difficulties of fading prints, breaking glass plates and tarnishing silver, photography was and is still referred to as a 'permanent record'.

Permanence, or the ability to be fixed, has often been used as an historical category, dividing 'successful' photography from other chemical imaging trials with light-sensitive materials. In the histories of photography, proto-inventors are commonly distinguished from inventors by the phrase, 'but he/she was unable to fix the image that formed'. It is a

very robust definition of 'fixing', one that could mean anything from days to decades, and indeed permanence in photography is quite relative. The early images conserved by Talbot are less permanent than, for instance, negatives on gelatin film, which in turn are surpassed by photographic prints made in platinum or carbon. Scientific archives, especially those conserved in the form of journals and atlases, place a premium on this sort of physical permanence, emphasizing the materiality of photography as an object that will, like any other object, have a physical life span.

Microforms, usually encountered as either microfilm or microfiche, are perhaps the most common use of photography in archives in the twentieth and twenty-first centuries (illus. 54). What microforms show us is a perfect example of one critical trait of the photographic record – it encourages us to look through the medium of photography, allowing us a supposedly unmediated look at the object it pictures. Nobody looks *at* microfilm, instead we look *through* it, to the book or manuscript it represents. Photography's ability to disappear like this is one of the traits that makes it valuable as a scientific record. Even in spite of the many photographic artifacts (smudges, flecks and black marks) that appear with great regularity on microfilms, the frames of a microfilm are very rarely looked at as photographs. Considering the first few frames of a microfilm is perhaps the easiest way to confront its photographic qualities. On every film you will find at least one frame meant to verify the accuracy of the photography. The control frame might have stripes, lines, circles or squares, or a text stating when and where it was made. This control frame asserts that the proportions of the original object are being maintained through the neutrality of the photographic medium.

54 Silver gelatin microfilm images from Charles Durier, *Histoire du Mont-Blanc, conférences du faites à Paris les 23 et 30 mai 1873.*

The sheer transparency of photography as a physical object is what is crucial to creating photographic records. It could be called one of the iconographic traits of the photographic record. Photographers striving to effect this photographic disappearing act use a number of techniques, among them neutral backgrounds and measurement indications (see illus. 58). These visual clues are provided so that we will look at the object of the photograph as we would an object or specimen in the flesh. Over the decades, an iconography of the specimen photograph has been de-veloped by various archiving projects in an attempt to do just what microforms do – that is, to make photography disappear – encouraging observers to look directly at the object, not at a photograph of the object.

The single specimen is a common form of photographic record found in archives. The specimen photograph is the single result of a ballistic experiment, a building facade, a portrait, an impression of a plant (illus. 55). Two photographs of the same painting could be two very different specimen photographs, one of the painting, one of deterioration of the paint surface. Specimen photographs can stem from both observa-tions and experiments and they have some visual traits in common. The most common form of creating a specimen photograph is to isolate the object of the photograph.

When it comes to depicting humans as specimens, photographers in the nineteenth century developed rigorous protocols that remain to the present day and have often been used in art and fashion portraiture.[9] The person is placed before a blank background and photographed in neutral lighting strictly from the front and in profile. The artistic three-quarter view and raking light beloved of studio photographers is rarely considered scientific enough, although studio portraits often also made their way into ethnographic and anthropological archives. Much of this sort of scientific portraiture was developed not in the context of anthropology, although some physical anthropologists employed such photographs, but in anthro-pometry. This title, coined by Alphonse Bertillon in the 1880s, refers to a system of measuring the human body for identification purposes, especially in law enforcement (illus. 56). Within this system, photography played the role of 'final identification' after a suspect had been located by a comparison of all the other measurements.[10] Although anthropometry

55 Ernst Mach, *Messingprojectil mit halbkugeligen Enden. In der Axe durchbrochen. Linke Blendung* (Measurement projectile with curved ends), 1888.

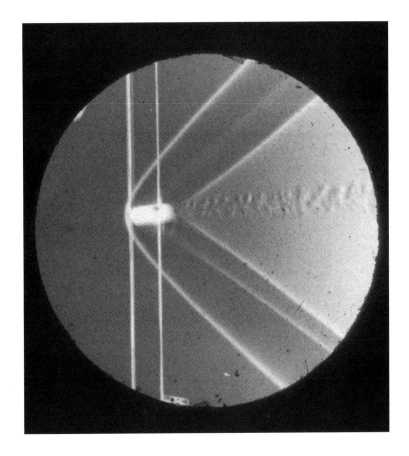

itself was rather unsuccessful and was replaced quickly by fingerprinting, the photographing of criminals became standard practice.

Bertillon's photography was coloured by his experience with photogrammetric practice, and he advocated the use of a head brace and a specific camera angle, controlling the photographic input as one would do with any photogrammetric exercise. He adapted the clear frontal view that was already a trend in the photography of non-Westerners. These views of inhabitants of colonized lands were not often made by scientists, but by studio photographers who were instructed in the protocol. Lieutenant-Colonel William E. Marshall, for instance, used images of the Todas living in south India made by Bourne and Shepherd, the studio of Samuel Bourne

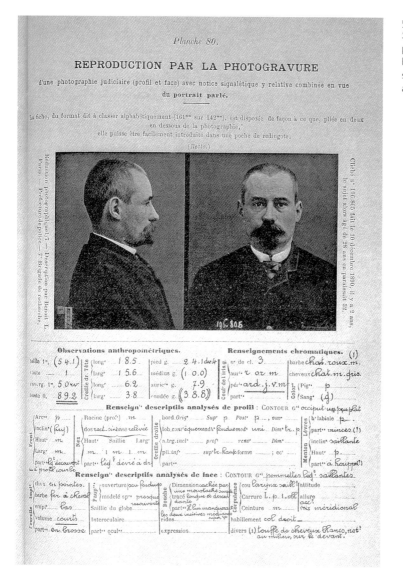

56 Alphonse Bertillon, *Instructions Signaletiques* album, 1893. Like his photogrammetric crime scene (illus. 25), Bertillon's portrait is tipped in to a standard form – a common practice in archives.

and Charles Shepherd, operating out of Calcutta and Simla (illus. 57). The Todas were a popular subject at the time for Europeans investigating tribal, social or religious customs. Marshall was neither the first nor the last to be attracted to this relatively isolated tribe in south India for the purpose of

57 Bourne and Shepherd, Plates 5 and 6, from William E. Marshall *A Phrenologist amongst the Todas or the Study of a Primitive Tribe in South India* (1873), collotypes.

writing travel, anthropological or anthropometric texts. Because they were often the property of the studio, and sold to third parties, these sorts of images were not confined to use in a single book but circulated throughout the anthropological community.[11] The gridded background of this image of a young woman made it easier to measure facial features of the subjects. Eugenics and the promulgation of racial typing adopted this iconography to great effect. What associates Bertillon with anthropologists like William Marshall and Carl Dammann, the editor of one of the largest books of racial types, are two things: the use of photographic portraits as specimens that were gathered into archives, and the many different sorts of consumption of these archives.[12] Not only do the look of the photographs reflect the recognition that photography, like any other imaging medium, needed to be first subjected to rigourous scientific standards before specimens of it could be compiled into a reliable archive, they also allow the images to become interchangeable by taking their subjects out of any local context and transferring them to a 'scientific' one. In this way Bourne and Shepherd's photographs of the Todas could migrate from one collection to another, and acquire a new context.

Measuring devices in specimen photographs don't have to take the form of a grid. They can also be step wedges, colour cards or any number of objects or devices. The greyscale and colour correction shown below the reproduction of Baldus' *Roman Arch* (illus. 58) is just such a device. Often, in the case of landscape or monument photography, humans were used to create a sense of scale. In colour reproductions, the colour chart acts as a control device, authenticating the accuracy of the reproduction. Even where these standards are rather loose, such as the use of a person to generate scale, we find the same visual rhetoric, one that stakes the claim of the photograph to be a specimen taken in the context of science.

Although techniques differed among photographers, the photographs of Édouard Baldus, in his work for the Mission Héliographique, closely resemble what we have come to recognize as the ideal specimen photograph. *Roman Arch* has all the ingredients of a specimen: isolation of the subject, sharp delineation and the presence of a single human for scale. Baldus' photograph has an additionally stark quality due to the lack of clouds in the sky. Although this bareness is common in many

58 Édouard Baldus, *Roman Arch at Orange*, 1851, salted paper print from a calotype negative, 35.3 x 26.2 cm. The digital reproduction of this image shows a standard greyscale and colour chart as used by most museums to ensure accurate photographic and print reproduction of the original.

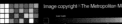

photographic records, here it is an artifact of the calotype process. Due to the sensitivity of the paper negative process to the blue and violet end of the spectrum, skies and landscapes required very different exposure times. In order to render a sky, the photographer would have to take two images, one of the sky and one of the monument, and combine them in printing. Baldus was well known for producing prints from multiple negatives to overcome deficiences in vantage points, but he has not done so in this view. Baldus' work for the Mission Héliographique made his reputation and he went on to a successful career in architectural and industrial photography, producing several thousand images of the construction of the new Louvre between 1855 and 1857.[13] The photographic record, seen through these examples, presents us with the rhetoric of scientific objectivity that was the subject of chapters One and Two. The passive photographer/observer gathers up as neutral a presentation as possible, neutral, that is, regarding lighting, background and point of view, in an attempt to render the photographic activity as transparent as possible.

Instruction and Knowledge

One of the common uses of specimen photographs is to create an inventory or a catalogue, what is referred to as an 'organic' archive. These catalogues and inventories are often goal oriented, carefully controlled and highly systematic. They can consist of photographs of objects *in situ*, or photographs of objects in museum collections, or even photographs of photographs, like many digital archives today. These catalogues often become the public face of the archive, and there is hardly a major scientific institution or project that doesn't have a gallery of photographic images for sale.[14] Just as in astronomy, many famous photographic names have been involved in the making of this sort of object inventory: Roger Fenton, the Alinari brothers and the photographers that worked for them, Eugène Atget, Berenice Abbott, Adolphe Braun, Gustav Le Gray, Édouard Baldus, Hippolyte Bayard, Henri Le Secq and Auguste Mestral. These last five were all engaged on the famous Mission Héliographique.

The Mission Héliographique was a project run by the Commission des

Monuments Historiques (Commission for Historic Monuments) intended to document French monuments that had been or were about to be restored. It was a highly directed, governmentally controlled project to create a photographic archive, and one of the very first. The task was simple: photograph French architectural monuments, ones that had been previously singled out for governmentally sponsored preservation, for the posterity of the nation, or the posterity of the governmental preservation unit. Like the survey images of the American West, this sort of archive exists to build national identity in a particular way. It was never meant to be a comprehensive catalogue of all monuments, or a complete map of a geographical area, but instead it was meant to bolster a preservation project already in progress. Taken out of context, individually, and as works of art, these sorts of images (from both the Mission Héliographique and the American Surveys) work quite differently than when they are taken together in a group.[15] Individually, their formal characteristics are emphasized at the expense of their didactic qualities, which emerge more strongly when the images are taken in series or groups.

One of the interesting effects of photographic archives is their tendency, either accidentally or intentionally, to form a very public visual canon of a certain field of study. This was particularly true in the sciences. Although many original scientific photographs have been lost, their mechanical offspring proliferate in journals and books. Journals like *The Archive of the Röntgen Ray* and *Le Radium* were not shy about clearly spelling out their purpose not only to disseminate information, but also to conserve it for posterity (illus. 59). In this way they also form archives of a certain sort, which mirror the ambitions of scientists for their fields of study and claim to provide a steady, secure knowledge base.[16] Atlases in particular contain images that often form the core or canon of a particular discipline.[17] Because atlases are so wrapped up in disciplinary identity, they are naturally also caught up in a fair amount of controversy. While one atlas claims to represent the core of study, another may refute that, claiming precedence for an entirely different set of images. Atlases employ all sorts of imaging techniques, and there is a whole genre of photographic atlases that gained popularity in the later decades of the nineteenth century and remain a staple of the Web today.[18]

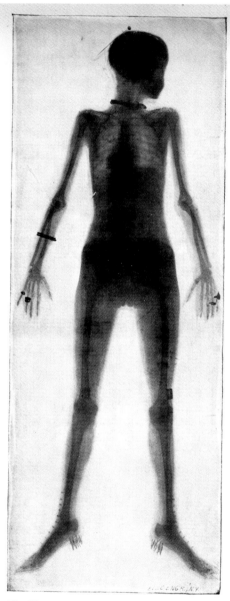

(Copyright.)

ENTIRE ADULT BODY AT ONE EXPOSURE.
(By WILLIAM J. MORTON, M.D., N.Y.)
PLATE XXX. (b)

59 William J. Morton, MD, 'Entire Adult Body at one Exposure,' *Archives of the Rontgen Ray* (1897), photomechanical reproduction.

60 Edward Leaming, *Atlas of Fertilization* (1895), Plate VIII, autotype.

39.
METAPHASE ENLARGED 3000 DIAMETERS. SPLITTING AND SEPARATION
OF THE CHROMOSOMES (P. 25).

30.
EARLY ANAPHASE, CHROMOSOMES SEPARATING. CENTROSPHERES (P. 26).

31.
LATER ANAPHASE. SYMMETRICAL GROUPING OF THE
DAUGHTER-CHROMOSOMES (P. 27).

32.
FINAL ANAPHASE. COMPLETE DIVERGENCE OF THE
DAUGHTER-CHROMOSOMES (P. 27).

One of the interesting features of photographic atlases of the nineteenth century is their attempt to demystify their own photography; to assure the reader that their picture-making is truly objective, mechanical and unsullied by retouching. This is the case with Edward Leaming's *Atlas of the Fertilization and Karyokinesis of the Ovum* (illus. 60). He notes the following:

The stain used by Professor Wilson being the iron alum and haematozylin stain of Heidenhain, the objects had a light blue tint by transmitted light; therefore isochromatic plates were used with a

97

colour screen made by dyeing a lantern-slide plate from which the silver salts had been removed with an alcoholic solution of tropae-olin, a cover glass being cemented to the plate by Canada bálsam which rendered the dyed gelatine quite transparent. A single solution hydrokinone developer, of a constant composition, was used, the exposure varying from three minutes with a fresh developer, gradually increasing to ten minutes as the developer became more oxidized.[19]

Leaming worked on several such atlases, and these remarks are typical, not only for his work, but for late-nineteenth-century photographic atlases

61 Edward Leaming, *Atlas of Fertilization* (1895), autotype.

NOTE ON THE PHOTOGRAPHIC TECHNIQUE.

The installation used in producing the photomicrographs of *Toxopneustes* was that manufactured by Zeiss of Jena in possession of the College of Physicians and Surgeons. In order to have as few variants as possible enter into the work, the following method of procedure and arrangement of apparatus was adopted and adhered to throughout. The adjustment of focus was left entirely with Professor Wilson as being most familiar with the special points desired; the exposure was then made so as to slightly overtime the plate, and it was subsequently intensified; where advisable Strong's adjustable false stage was used in order to bring into the same focal plane a second or third point of interest, and it was found that notwithstanding the short working distance of a 2 mm. lens the slide could be considerably tilted. The optical combination was an Abbe substage condenser achromatic 1 N.A.—a Zeiss 2 mm. oil immersion apochromat and projection ocular No. 4. The camera length was so adjusted that the image represented a magnification of the object of 950 to 1000 diameters. The illuminant employed was the electric arc, which was modified in the following manner. The condenser and objective were so focussed, that the image of the crater was projected with the image of the object on the focussing screen; a finely ground glass screen was then interposed in the path of the light rays near the condenser; this not only gave an evenly lighted field, but prevented the formation of rings or lines by diffraction. The stain used by Professor Wilson being the iron alum and hæmatoxylin stain of Heidenhain, the objects had a light blue tint by transmitted light; therefore isochromatic plates were used with a colour screen made by dyeing a lantern-slide plate from which the silver salts had been removed with an alcoholic solution of tropæolin, a cover glass being cemented to the plate by Canada balsam which rendered the dyed gelatine quite transparent. A single solution hydrokinone developer, of a constant composition, was used, the exposure varying from three minutes with a fresh developer, gradually increasing to ten minutes as the developer became more oxidized. I cannot help alluding here to the excellence of the sections from which these photomicrographs were made, the perfection of which, in every part of the technique of cutting, staining, and mounting, was such as to make working with them a pleasure. In no case have the negatives been retouched or even spotted.

May, 1895. EDWARD LEAMING.

vii

in general. Authors of these books often used an entire page or section to explain their photographic process in minute detail. Often the printing was done in some form of carbon printing or photogravure, and weight was given to the accuracy of the reproductions and to their unmediated, unretouched qualities. The preparation of specimens for microscopical work, which was equally complex, usually came under a separate heading. In this explanation, we can begin to understand the difficulty of making the photographic document completely transparent. In order to differentiate the parts of the slide specimen, the specimens are dyed. This dye must, in turn, be picked up by the emulsion, in this case an isochromatic emulsion. In more contemporary atlases, made with both analogue and digital photography, this is still how photography is used. Scientific atlases were made for fields ranging from astronomy to zoology, and together they form an immense pictorial canon of science, from which students and professionals alike draw many of their associations.

A didactic enterprise similar to the scientific atlas was the building of the canon of art history by way of photographs. Perhaps no two of these undertakings are more famous than Aby Warburg's *Bilderatlas* and André Malraux's 'musée imaginaire'. Warburg conceived of the *Bilderatlas*, the Mnemosyne as he called it, as a memory board of images that, combined, served to highlight the relationships of human psychology through images of art. Needless to say, this type of picture assemblage could also constitute a map of images of a certain time period. Photography of the subjects not only reduced the size of objects, it also brought them into the same flat dimensions, making it much easier to compare and contrast art works of vastly different scale, visibility and corporeality. A miniature painting could be compared to a marble bust, so long as the bust was photographed appropriately. That one of the objects was three-dimensional and the other only two-dimensional has only recently come to be an issue.[20] The art historical method of comparing works of art side by side via slide projection would be impossible without it (illus. 62).

Malraux believed that the store of remembered images influences the way we see and perhaps also learn from new images. He used photography as an *aide-mémoire* to facilitate this method of learning and to compile his books. He took on the idea of photographs as multiples,

challenging the common use of one photograph to tell one story. Malraux insisted that it was impossible to unhinge one image from the whole, closely approaching the idea that the archive of images has something to teach that single images not only *do* not, but *can*not. The quality archives have of offering learning from a large group of images lifts no particular one up into the spotlight above the others as an iconographic image.

Photographic archives create knowledge out of their individual records in quite different ways, because they always exist as a complex of images, rather than as single images. In the case of a single image, say plucked from a whole experimental series, the single image acts as a symbol for the entire series (see illus. 41). Like Becquerel's ideal images of radiation, showing alpha, beta and gamma radiation, the iconic image sums up the whole in one image although there are many more photographs made in the actual process. The photographic record forms knowledge in archives, not by becoming iconic or being used singularly, but by sinking in among its companions, relinquishing its individual character in order to further a much larger narrative history. Often, this larger history is one bound up with a particular disciplinary identity. The epistemology, that is, how scientists get knowledge from these collections, is complex because an archive is always a collection. To put it another way, archives consist of multiple images, sometimes huge numbers of them, sometimes just a handful. Together they constitute a certain sort of visible memory, or a visual method of problem solving.

In this use, photography has a particular advantage in that it records not just the details of interest at the time, but *all* the details a given film is capable of in a given set of circumstances, and this lends photographic archives a particular flavour.[21] The vertiginous pace of scientific change that occurred in the second half of the nineteenth century guaranteed that at the very time when photography was being introduced to archive building, the need for creating archives on which new theories could be tested was growing. Scientists became more convinced that theories would be overthrown or revived and were determined to leave behind archives of material that tacitly acknowledged this state of flux. Photography was on hand, offering a new way of achieving an archive, one that could retain accidental information along with the intentional.

62 Kelley Wilder, *Michelangelos*,
Kunsthistorisches Institut, Florence, 2008.

Notorious for their relentless and indiscriminate capture of detail, photographs embodied the notion of archiving for the future, for a science based not only on the accumulation of known knowledge, but also on the examination and re-examination of that knowledge in the face of new discoveries.

Art and the Scientific Photograph

What twentieth-century art is *not* influenced by modern science?
James Elkins[1]

Photography plays a key role in art/science debates of the nineteenth, twentieth and twenty-first centuries. These debates, ranging from arguments about how similar art might be to science (or vice versa), what their influences on each other might be, and how the two might be seen as less oppositional, have to a large extent been taken up from the side of art. This is especially so as artists increasingly address science directly as a focal point for their art. Common questions arise in this debate: are scientific creativity and artistic creativity similar? Do art and science images share iconographies (or an aesthetic)? And finally, can artistic and scientific modes of thought lead to problem solving in each field? Coalescing into a mature dialogue in the 1940s, this field of research has been addressed by scientists, historians of science, philosophers, artists and historians of art, among them C. P. Snow, Arthur I. Miller, Grygory Kepes, Thomas Kuhn, Judith Wechsler, Bruno Latour and Martin Kemp.[2]

Photography also has its own internal art/science debate that sometimes, but not always, reflects the concerns of the broader discussion delivered by these authors. For two decades, in the 1850s and '60s, photography suffered under an acute identity crisis. It was born of science, used in industry, but employed by largely amateur artists, not as a means to an end but as an end unto itself. In these twenty years and into the 1870s photographers sought to define their activities. Photography in the World's Fairs of the 1850s (Crystal Palace of 1851 in London, and the

Exposition Universelle in Paris in 1855) was exhibited among weaving machines, book printing inventions, ironmongery and steam engines in the pavilions of Industry. Although these exhibitions were tremendously influential in enhancing the public opinion and knowledge of photography, photography itself was clearly separated from the fine and decorative arts. Even later in the Paris Exposition Universelle of 1867, photography was placed in its own space, halfway between the Industry and Beaux-Arts pavilions. Ambiguity in these World's Fairs was mirrored in the debates found in the popular and photographic press. Photographers formed associations, founded journals, held exhibitions, wrote criticism and often tried to distance themselves from their scientific and industrial roots, but to no avail. Art critics, in particular John Ruskin, both praised and condemned photography for its mechanical fidelity.

These few isolated decades, even taking into account their formative nature, have had an inordinate influence on the treatment of photographic history. In the attempt to better the reputation of photographic artists, and to legitimize photographic history as a part of art history, a strict division arose between what is seen as scientific and what is seen as artistic in photography. Many photographic collections reflect this strict division, as do many histories of photography. It seems doubtful, however, that science and art can be, or ever ought to be, cleanly divided in photography. This is because unlike other visual arts, photography is not only a method for *illustrating* science, it is also a method for *doing* science. Put another way, photography is both an art *and* a science, and it is this dual role that artists and scientists frequently employ.

The point at which science leaves off and art begins is often muddied by scientific objects, like E. J. Marey's photographs, that become part of the artistic cannon. Aaron Scharf's oft-cited book *Art and Photography* even went so far as to use the graphic generated from a Marey chronophotograph to illustrate the frontispiece (illus. 63).[3] Marey's image, a study of human physiology, is here employed as the poster child for art photography (illus. 64). This chapter addresses the way in which scientific themes have continuously cycled through art photography, from the earliest decades to the present. Sometimes science takes a leading role, when scientific images are appropriated into art

Penguin Books **Aaron Scharf** **Art and Photography**

63 Title page of Aaron Scharf, *Art and Photography* (1974).

situations or when art movements arise – like that of the 'esthetic scientist' of the 1990s – but even in photographic movements purportedly given over to the concerns of 'fine' art, like pictorialism, science can be found lurking in the background.

There are several ways to consider the art/science debates in the context of photography. In the first case there is the incorporation or appropriation of scientific photographs into art institutions or the art market. The second is the use of the iconography of scientific photography in art, and artists' direct investigation of scientific methods. In the third case, there is the use of scientific concepts like observation, experiment and archiving in the making of art. In this last category, artists engage concepts important to science in order to engage in a critical dialogue about the modern world and its scientific concerns.

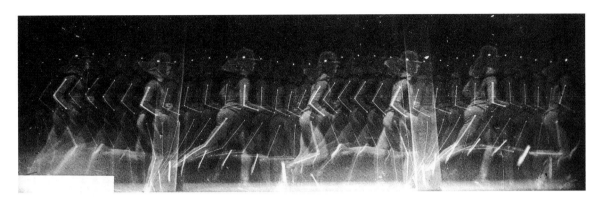

64 Étienne-Jules Marey, *Chronophotographie sur plaque de verre: Morin, course de vitesse, 18 juillet 1886*, (Chronophotograph on a glass plate: Morin, moving at speed, 18 July 1886).

Beauties of Nature

Romantic notions of the truth and beauty of nature strongly influenced the first observers of photographs. The new art evoked two things, the beauty of the natural, shown without artifice, and the elegance of her underlying laws, shown without bias. Talbot's early emphasis on the removal of the hand of the artist from the photographic process was no more and no less than an appeal to the unmediated beauty offered up in the most sublime natural displays from picturesque landscapes to microscopical illuminations. Although the notion of beauty and mechanization proceeding hand in hand from the same instrument was always going to be a contentious point for artists and critics addressing photography for the first time, many of the early photographers evinced no such qualms. They were used to marvelling in the purely natural, whether it appeared in a sunset or in the projection of a spectrum. Harnessing the natural through a machine or a contrivance expunged none of the original mystery or attendant beauty of natural objects.

Natural theology, the belief that evidence of the divine could be found in the study of nature or natural forms, was a late eighteenth- and early nineteenth-century movement that helped to bolster this sense of wonder. Not that all photographers of the nineteenth century were natural theologians, far from it. But the lingering sense of divine nature, presented through photography in a nearly infinite multitude of details, remained, even when natural theology went out of fashion in the late

73: 250:102

65 Frederick H. Evans, *Photomicrograph*, gelatin silver print, negatives of this series and silver prints made before 1886.

nineteenth century. Photomicrographs are most often the focus of these debates, images from the microscope having fascinated the public since the publication of Robert Hooke's lavishly illustrated *Micrographia* in 1665. It was Hooke who instituted the famous circular iconography that was intended to simulate the view down the barrel of the microscope, an iconography often reiterated in the presentation of round photomicrographs. But the photomicrographs are even more redolent of the investigation of natural forms, even at the most minute level (illus. 65). The discovery of

basic, repeating, geometrical forms in the eye of a fly, or in the spine of a sea urchin, were a constant source of wonder, and these images were often exhibited and judged on their aesthetic merits, although they were often made in the service of science. Photomicrographs are one of the most commonly exhibited photographs even in the present day. Nikon's Small World photomicrography competition has been running since 1974, awarding prizes to photographs made with light microscopes every year.[4]

The art/science debates of the mid-twentieth century on form, pattern and structure, that is, on morphology, in both science and art, is often said to be rooted in D'Arcy Thompson's influential *On Growth and Form*, first published in 1917.[5] Thompson studied the mathematics underpinning biological forms, and most famously compared related forms in an attempt to explain the natural forces that had given rise to them. Thinking along these lines can be traced much further back to Goethe's notion of the *Urform*, the true form of a plant, and it appears also in work by Ernst Haeckel. These, along with the German Jugendstil movement that appropriated so many natural forms, are the antecedents to one of the most influential bodies of work in this area of photography, that of sculptor and educator Karl Blossfeldt (illus. 66).[6] Consisting of loose photogravure plates, *Urformen der Kunst* was not so much a book as it was a collection of photographs meant for use in a classroom, retaining some of the original teaching purpose of the glass plates Blossfeldt made over several decades. Taken in his studio under the stringently similar conditions necessary for specimen photographs (always in indirect daylight, always with similar glass plates, always with a blank background), Blossfeldt used his archive of lantern slides for teaching students about plant forms at the Hochschule für Bildende Künste in Berlin, where he taught from 1899.[7] Although these images were first published in the 1920s, Blossfeldt had been making them, as well as sculpting plant forms, for many decades. The published work in both *Urformen der Kunst* and *Wundergarten der Natur* makes up only a small fraction of his life's work.[8]

The 1920s were something of a heyday for the scientific photograph in art, especially as concerned with natural forms. Shortly before Blossfeldt's first book was published, László Moholy-Nagy brought out his 'New Vision' for photography in the treatise *Painting, Photography,*

Film.[9] 'New Vision' not only encompassed the Bauhaus ethic of the usefulness of both industrial and scientific photography, it also adhered to a strong biocentric strain of Constructivism that was especially prominent in the Weimar Republic at the time.[10] It called for the appreciation of the formal visual aspects of scientific photographs and for the use of scientific technologies like x-rays and photograms to make art photographs. The book was a manifesto for the revelation of underlying natural structures via scientific photography. This revelatory quality attributed to photography is a theme that is frequently brought up in both art and science.

66 Karl Bossfeldt, *Polypodium vulgare, Ribes nigrum, Pteridium aquilinum*, 1928, photogravure.

67 László Moholy-Nagy, *Photogram IV*, 1922 (c. 1930 printing), gelatin silver print.

Moholy-Nagy and contemporaries Christian Schad and Man Ray all adopted the photogram as a method for employing 'scientific' iconography (illus. 67). 'Photogram' is the terminology used in art for any cameraless image. Although the same technology is often employed to make images for scientific purposes, these are rarely, if ever, called photograms, perhaps precisely *because* the word was invented within the arts. In the nineteenth century, 'photogram' was employed to mean any photograph that had art potential, hence *Photograms of the Year*, the London publication of the best pictorial photographs. Cameraless images have had many beguiling names: luminogram, radiogram, rayograph, celestograph, schadograph, actinograph and many more. In the 1920s the term 'photogram' finally emerged to cover all cameraless experiments. Ironically, although photograms often refer to science through their cameraless nature, science photography rarely makes a distinction between images made with and those made without a camera.

There are many purely visual attributes borrowed by artists to conjure up scientific overtones. The stripes of a DNA sequence or the grey, half-transparent look of an x-ray are immediately recognizable as belonging to science (see illus. 1). The microscopical circle is another, as are photograms, and frogs, the original experimental animal (illus. 68). Frogs were both observed by naturalists of the eighteenth century and experimented on by scientists investigating electricity and magnetism in the early nineteenth century. Susan Derges has evoked this age-old method of observation in the series *Vessel no 3*, one section of which is shown here. The life cycle from spawn to polliwog to frog to death is here recreated in a series that invokes the attentive looking required of observation, and the use of photographic recording of the observations. Derges not only examines the scientific practice of observing, but the role of photography in that practice. Similarly, Michael Marshall opens a dialogue about collecting and taxonomy in his *Bird Specimens* (illus. 69). Photography is self-reflexive in these works. It documents a scientific process like observation or collection and archiving, in which it also often plays a key role.[11] Marhsall's use of the blank background desirable for specimen photography is countered by the inclusion of not one object, but many. What is on display is not the specimens, but the process of

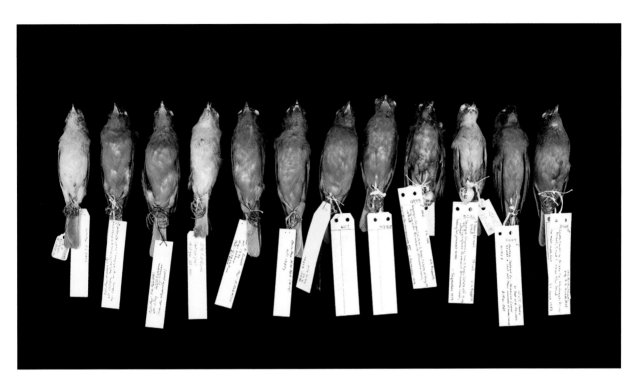

69 Michael J. Marshall, *Bird Specimens*, 2004, inkjet pigment print on wood panel.

opposite: 68 Susan Derges, *Vessel No 3* (detail), 1995, Camera-less dye destruction print.

doing natural history. Not all sciences are so easy to invoke. Subhankar Banerjee's Arctic photographs are inspired by ecology, and photography of the tenuous natural balances of the Arctic are no easy task for photography (illus. 70). It is not clear that all images that look like a particular set of scientific images are actually referring to them. Garry Fabian Miller's photograms can look remarkably like x-ray diffraction photographs, both in the rings and in the points of light, although they are inspired by landscape, colour and light (illus. 71, 72). Because Fabian Miller's photographs of this series investigate the properties of light, and with them the properties of diffraction, often through liquids, the photographs look like science photographs because they have the same object in view – light and a photochemical reaction.

Probably the most recognizable use of scientific photography in art is the standard x-ray. When Robert Rauschenberg decided to make a life-size, full-body x-ray for his 1967 lithograph series *Booster*, he introduced,

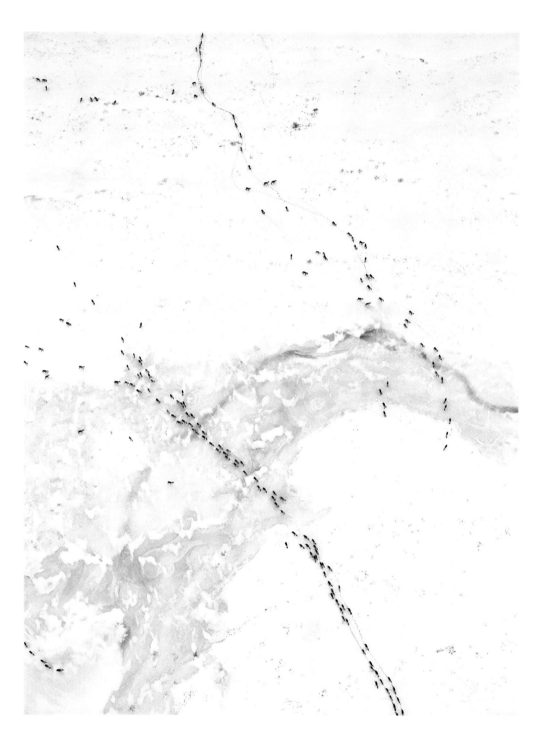

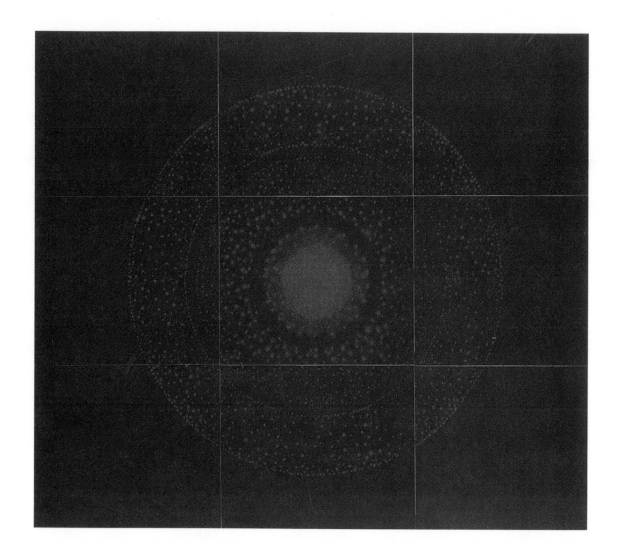

71 Garry Fabian Miller, *Nine Hours of Light*,
3 July 2005.

70 Subhankar Banerjee, *Caribou Migration 1,
Oil and the Caribou*, 2002, C-print, 86 x 68 ins.

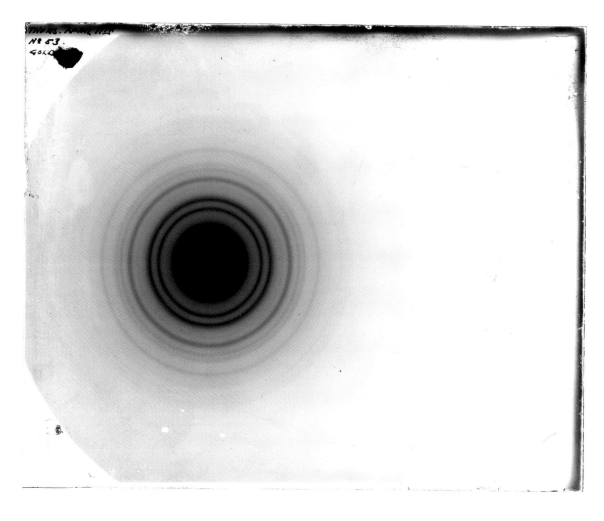

or rather reintroduced, the x-ray to art (illus. 73). In the nineteenth century, and during the avant-garde period of the 1920s, x-rays were popular subjects for their strange otherworldly aesthetic. Many x-rays, even in the context of medicine, were made specifically with optical effect in mind, in part because 'better' x-rays could mean clearer diagnostic capability. But the more one looks at the x-rays before the avant-garde, the more it becomes clear that people simply found them beautiful (see illus. 34). Authors of x-ray images, like William Morten, claimed copyright for

72 Photographer unknown, *X-ray Diffraction of a Gold Sputter.*

73 Robert Rauschenberg, *Booster*,
from the series Booster and 7 Studies,
1967, colour lithograph and screenprint.

74 Arthur von Hippel, *Lichtenberg Figure*, 1936.

their images (see illus. 59). It has often been the case that scientists who began making photographs for experimental purposes found them so beautiful that they carried on making them as a form of art. Berenice Abbott and Harold Edgerton's stroboscopic photographs fall in this category, as do the Lichtenberg Figures of Arthur von Hippel. Made in the 1930s in a gas chamber at MIT, with the help of his assistant Fred Merrill, von Hippel's figures show the effects of both positive and negative charges in various gases under various pressures (illus. 74). He found them so beautiful that he continued making them long after his research had ended. Hiroshi Sugimoto has recently revisited these figures in the series *Lightning Fields*, taking up again the appreciation of beautiful and generative forms in natural forces.

Revelation and the Art of Photography

Science has always had a great influence on the making of art photography, although exactly what sort of influence is impossible to generalize. Consider the curiously opposing reactions of P. H. Emerson and Frederick Evans to the scientific debates on emulsion sensitivity. Emerson was well known for his photography of the Norfolk Broads and as the eccentric author of both *Naturalistic Photography* and *Epitaph in Memory of Naturalistic Photography*. Having misunderstood some of the more complex arguments in Hermann von Helmholtz's *Treatise on Physiological Optics*, Emerson published in 1889 a philosophy for a new type of photography called, as the title indicates, naturalistic photography. In the book he sought to build a theory of 'true' photography (what we might call straight photography) on the idea that the human eye has only one part of the picture in focus at any given time. To give the argument in short, Emerson believed that Helmholtz's theory of physiological optics rested on this singular fact. He also believed whole-heartedly in the camera-as or photography-as eye analogy. Because photography was or at least should be an extension of human vision, Emerson believed photographers ought to strive to imitate this 'natural' vision as closely as possible. Thus he advocated softer focus in most parts of the image, those that

were not the focal point. At the same time he dismissed photographers
that went about constructing photographs out of multiple negatives, like
Henry Peach Robinson and Oscar G. Rejlander. In addition to attacking
those montagers, Emerson dismissed photographers like Robert
Demachy or Heinrich Kühn, who altered their prints to resemble either
painted work or etchings and engravings.

In May 1890 Ferdinand Hurter and Vero Charles Driffield, colleagues
at the Gaskell Deacon works in Widnes, Cheshire, published their first
results about the correlation between silver deposits and exposure times
in photographic emulsions. The curve they introduced to show the
relationship between density and exposure, beginning with the 'toe' and
ending in the 'shoulder', is usually called the H & D, or characteristic,
curve (illus. 75). Their research marked the beginning of measuring the
speed of films, because a different curve is applicable to each type of
emulsion. Once the curve for a particular emulsion is known, it can be
assigned a 'film speed'. In order to represent the relationship of light to
shade in a natural scene, the photographer would have to know the
characteristic curve of the emulsion at hand, and use the correct exposure
accordingly. Hurter and Driffield's most controversial claim was that the
influence of subsequent development of the image is only minimal.

Emerson, on reading these results, felt that his inability to control
every nuance of emulsion activity barred his photographs from the realm
of art. But what he was really concerned with was how true the images
might be in relation to human vision. He saw that as long as emulsions
were adhering to a set of chemical rules based on larger physical princi-
ples, he would not be able to represent in photographs what the eye saw.
Since this correlation between the eye and photography was where art
was located for Emerson, he concluded that naturalistic photography was
unachievable.[12] He then wrote the *Epitaph*, a mere two years after
introducing naturalistic photography. Driffield perhaps summed up
Emerson's greatest fears in an article in 1903, when he wrote,

> Whilst the artist also looks for truthful drawing, he, in addition,
> seeks truth to nature from another point of view; he requires light
> and shade to be rendered as it is seen by the eye: he looks for truth in

FIG. 68. Characteristic *D* log *E* curve.

75 C. E. Kenneth Mees, *Characteristic D log E curve.*

tone. But while great perfection has been reached in correctness of drawing, the truthful rendering of tone is still more or less a matter of chance: and indeed, so long as our plates are less sensitive to light of great wave length than to light of short wave length, absolute truth of tone will not readily be obtained.[13]

Frederick Evans was also deeply interested in control of photographic tonal scales. In particular, he was interested in the notion that photography, through its reproduction of the natural tonal scale, could reveal the underlying structure of objects in the world. Evans was a great believer in the notion of *Urforms* in nature (his writing has very clear overtones of natural theology), and he believed photography could be just the tool for getting at these forms.[14] Simply put, his belief was that the real truth of photography lay not only in the formal beauty of the object (microscopical or architectural) but in the greyscale achieved by a combination of proper negative exposure and appropriate choice of printing material. The 'reality' of a photomicrograph, or what would now be considered its ability to generate knowledge, could, according to Evans, be measured by two things; the accuracy of the tonal scale and the relationship of formal pictorial elements.

It isn't particularly well known that Evans, who made his reputation in architectural photography, began his photographic career in 1883 making photomicrographs. They were so good that he was awarded a medal for them by the Royal Photographic Society in 1887. The connections between art photography and microscopy were quite strong in Great Britain at the time. Indeed, when the Photomicrographic Society of London was founded in 1911, all of its principal committee members were also members of the Royal Photographic Society. Many had wondered then, as they still do now, at the beauty of the microscopical images appearing in journals and exhibitions in Britain. Evans claimed he was led to microscopy by his 'life-long love and study of "the beautiful"'.[15] But his rhetoric speaks more about the truth in photography than the beautiful. In order to achieve the ideal tonal reproduction, Evans exposed his photomicrographs with carefully adjusted light and he printed them exactly, either in Woodburytype positives on glass

73:250:42

Tr: sec Spine of Echinus ×.22

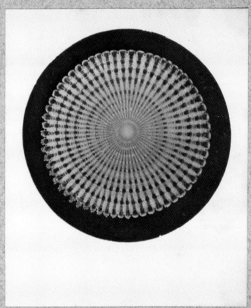

73:250:42 b

ditto

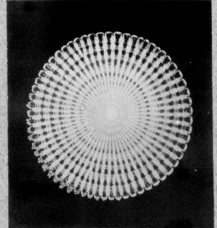

73:250:42 a

ditto

(for showing as lantern slides) or on silver paper (illus. 76).[16] Years later, in 1914, he reprinted the same images in Satista Platinotype, testing the capabilities of platinum against the silver. This spine of a sea urchin occurs again and again in his album of photomicrographs, photographed in different dark ground illumination (for instance with reflected light or a spot lens), presented both square and round in format, and printed in various ways with both silver and platinum. The album itself reveals Evans' fascination with the confluence of form and tonal gradation.

In 1905 Evans explained just why he felt that glass lantern slides, projected, were the perfect expression of the photographic medium. It was his opinion that photography was

> essentially a means of the perfect rendering of half-tones, of detail, of gradation . . . not, as in etching, a means of saying things by line, or by suggesting things by spaces; . . . not, as in engraving, a means of showing things by a multiplicity of lines, or of fine hatching, or dots, etc.; it is not, as in wash-drawing, a means of giving bold or tender masses, nor is it akin to pencil-drawing, or pen-and-ink work, or to lithography . . . [photography's] legitimate path is the dealing with abundant detail plus a wealth of, indeed an entire dependence on, gradation, on half-tone, as it is called, in which the detail is more or less importantly given.

Which is why glass, especially the projected photographic positive on glass, was the ideal medium. It 'suggested the natural depth of the photographic image, which is never a surface image, as in a drawing'.[17] The placement of the object of the photograph and the manipulation of light would become a trademark of Evans's later architectural work. For Evans, the Hurter and Driffield reports were only an incentive to more control of lighting and exposure and to the choice of appropriate printing materials. In these two cases, and in other historical examples, it is impossible to extract a simple theory of the influence of science on art photography. For some they are a stumbling block, and for others an inspiration.

The Science of Art Photography

There are many points at which art photography has shown the marked
influence of the scientific concepts of observation, experiment and archi-
ving. Observation is perhaps the most often met, in work like Alfred
Stieglitz's *Equivalents,* that look so much like atlases of cloud formation
used in meteorology, or Andy Warhol's epic film *Empire,* a steady 485-
minute shot of the Empire State Building at night – the epitome of patient,
indefatigable observation. Lesser known perhaps are the use of experi-
mental concepts or archiving concepts in creating bodies of art.

In the twentieth century the photographic emulsion became not just
something to make observations with, it became an experimental field
for art. Surrealist photographers like Man Ray and Raul Ubac used *brûla-
ge* and solarization, heating the emulsion to buckling point or 'flashing' it
with light during development, to produce photographs that told some-
thing about the physical photographic object. The images were only
partly (in the case of solarization) or not at all (in the case of *brûlage*)
dependent on camera equipment and lenses and pictures. More impor-
tant than depicting a pictorial scene was engaging directly with the
photographic surface. This practice of interference in the photographic
emulsion has had a renaissance since the 1970s.[18] Art of this sort puts
aside the rhetoric of observational photography (unmediated, passive,
mechanical) in favour of a more experimentalist rhetoric of active inter-
vention. Of course, the making of photograms is the most popular way of
achieving these works. Artists tinker with the sacrosanct emulsion, placing
organic matter on it to make marks that represent a level of chemical
interaction unseen in photography since the heyday of experimental
emulsion-making in the mid-1950s. Adam Fuss has created photographs
by letting mushrooms grow for months on black and white paper, and
Daro Montag has placed slices of kiwi directly on Ilfochrome paper,
creating direct positive photograms in colour (illus. 77). What Garry
Fabian Miller does with his hours of exposure is what emulsion scientists
have always done in testing and stretching the silver halides. The author-
ity these images carry as photograms is subtler than the authority in
camera images. It depends on a certain immediacy and authenticity but it is

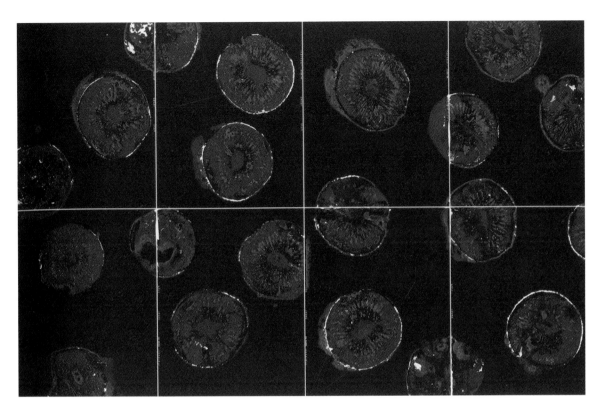

77 Daro Montag, *K3*, 1999, dye destruction print, on aluminium.

crucially enhanced by the introduction of happenstance and accident. Where the photographic experiment in science depends on its replicability and thus on the demonstration of control, the photographic experiment in art is quite the opposite. It gathers authority from the demonstration of chance. 'Mere' chance then is no such thing, it is instead a powerful rhetorical tool. Chance of course has always existed in scientific experiments as well, but if it was acknowledged it was couched in terms of serendipity. No scientist wanted to be known for discovering things 'only by chance'.

Quite the opposite of leaving things to chance is the practice of rephotography. With the many notions of archives driving rephotographic projects, there are of course a wide range of subjects that rephotography addresses. LANDSAT could be considered a rephotographic project, albeit

without the artistic intent, so could Nicholas Nixon's *The Brown Sisters*. The cinematic and repetitious qualities of these types of rephotographs lends them an authority by way of invited comparison. One image stands next to another of the year before, or ten minutes later. The original image, self-contained as it was, is then broken out of its isolation to create a dialogue with both the past and potentially with the future.

When Mark Klett, JoAnn Verburg, Ellen Manchester, Gordon Bushaw and Rick Dingus set out to rephotograph the American West in the Second View project, they were embarking on just such an exercise.[19] The project was to follow in the footsteps of the nineteenth-century

78 Timothy O'Sullivan, *Crab's Claw Peak* (now known as Karnak Ridge), Western Nevada, 1867, albumen print.

79 Mark Klett et al., *Mathematical techniques and measurements used to check the accuracy of the vantage point at Karnak Ridge for Second View*, 1977, polaroid.

surveyors of the American West. These images, taken for the United States Geological Survey, became icons of the American landscape, and the places they depict are often tourist highlights to this day (illus. 78). In 1867 Timothy O'Sullivan travelled to Western Nevada as part of the Geological Explorations of the Fortieth Parallel, led by Clarence King. His photograph of Karnak Ridge was one of many from a survey lasting several seasons. In order to rephotograph this image for the Second View project, the participants needed to find exactly where O'Sullivan's camera had stood. They had to organize what they called 'the geometry of the vantage point'.[20] The geometry here must cover not only the physical

installation of the camera, but the tilt and swing of the view camera, the focal length and focal setting of the lens, the height of the camera body. Each check of one of these details brings to the fore all the minute but crucial decisions that go into taking a survey photograph. By exposing the manipulations made by a single photographer to achieve certain iconic images of the American West, the Second View project has made it easier to take the subject of artistic style in archives seriously.[21] The original photographs are touted as unmediated, passive, observational views, and the activity required to successfully rephotograph them calls their status into question. The Second View participants' highly regulated

80 Gordon Bushaw, for the Rephotographic Survey Project, *Second View*, 1979, silver gelatin print. Karnak Ridge, Trinity Range, Nevada.

81 Mark Klett and Bryon Wolfe, for the *Third View Project*, 1998, colour print. Karnak Ridge, Trinity Range, Nevada.

photography matches techniques used for photogrammetric surveys, where the camera needed a secure setting in order to produce the desired result (illus. 79, 80). Visible landmarks, shown circled, are measured against the original image, one measurement extending more or less across the horizon, and the remaining forming part of a grid. The ratio of the various segments of line should correspond as closely as possible to the original photograph. The final view, taken by Gordon Bushaw, comes as close as possible to O'Sullivan's original vantage point. For the Third View of this landscape, colour photographs were also made (illus. 81).

Second View and Third View combine a nearly endless reflection on the scientific themes presented in this book, and we can take them one by one. Two elements of observation are evident here: the historical assumption of passivity and through that, objectivity, inherent in photographic surveys of landscape; and the creation of objective, measurable photographs. Equally present is the concern with photographic control important to experimenting. Perhaps the strongest reference however, is to the state of the photographic record, and the transparency of the act of photographing in a scientific context.

Photography as we know it has been shaped and continues to be informed by both art and science, which work together in complex ways. For photography, it is immaterial if the origins of an image lay, at a given point in time, wholly in science, or wholly in art. What is important is the exchange between these two fields. Photography derives much of its power from facilitating this exchange.

Glossary

Artifact A visible sign of the process by which an image is made. Artifacts can be a result of the camera or lens technology, the exposure, the emulsion or the development of the film. What is an undesirable artifact for some is a useful piece of information for others.

Collodion A generic term for any process using collodion as a binder for the light-sensitive silver salts. Collodion lay at the heart of many negative and positive processes on glass and paper following its introduction in 1851. Various adaptations were devised, and broadly fall into two general categories; wet collodion and dry collodion. For an account of this process see Thomas Sutton, *Dictionary of Photography* (London, 1858), pp. 121–40.

Daguerreotype Developed by Louis Jacques Mandé Daguerre and Joseph Nicephore Niépce in France in the 1820s and 1830s, the daguerreotype was announced to the public 7 January 1839 in Paris. A daguerreotype is made by exposing a silver-coated copper plate to iodine fumes alone or iodine and bromine fumes. It is then exposed, developed in the fumes of hot mercury and fixed in a salt solution (usually sodium thiosulfate). Most daguerreotypes are then gilded in a gold solution to intensify the image. For an account of this process see M. Susan Barger and W. B. White, *The Daguerreotype* (Baltimore, MD, 1991).

Gelatin-bromide emulsion A generic term for a photographic emulsion of silver bromide suspended in gelatin. The development of the gelatin bromide emulsion led to a great step forward in film sensitivity, and these plates were also often named 'rapid' plates or astronomical films. For use in astronomy they were also often baked at high temperatures to increase their sensitivity.

Isochromatic Emulsions that are sensitive to the blue/violet and UV parts of the spectrum.

Lichtenberg Figure So-called because of its discovery by Georg Christoph Lichtenberg in 1777, these figures are made when electricity meets an impressionable substance (earth, skin, a photographic plate, plastic). The figure is made by electrons rushing either toward the point of discharge (if it is positive) or away from it (if the discharge is negative), and it can be influenced by many surrounding factors, including the atmospheric situation of the discharge, the strength of the discharge and the material on which the discharge is made.

Orthochromatic Emulsions sensitive well into the green part of the spectrum.

Photogrammetry A way of measuring either buildings or landscapes by photography.

Photolithograph A generic term for any photomechanical process that uses a photographic emulsion to produce a planographic plate that can then be inked to create a positive on paper.

Raman Spectroscopy A method of spectroscopy using monochromatic light sources and inelastic scattering, used in condensed matter physics and chemistry to study vibrational, rotational, and other low-frequency modes in a system.

TRACE Called the Transition Region and Coronal Explorer, this NASA satellite was launched into orbit around the Earth in 1998. It is used by solar physicists and astronomers to study the sun and solar events (like the transits of Venus and Mercury).

Transit A transit occurs when a planet passes over the face of the sun, between the earth and the sun. Venus transits occur in pairs 8 years apart, either every 121.5 years or 105.5 years.

References

Introduction

1 There are, of course, notable exceptions in both fields, such as Lorraine Daston and Peter Galison, *Objectivity* (New York, 2007) and Martin Kemp, *The Science of Art* (London, 1990).
2 François Arago, 'Fixation des images qui se forment au foyer d'une chambre obscure', *Comptes Rendus*, VIII, no. 1 (7 January 1839), pp. 4–7.
3 Jennifer Tucker, *Nature Exposed* (Baltimore, MD, 2005), chap. 1.
4 Ann Thomas, ed., *Beauty of Another Order* (New Haven, CT, 1997).

one: Photography and Observation

1 John Gribbin, *In Search of Schrödinger's Cat: Quantum Physics and Reality* (London, 1984), p. 3.
2 The idea that the machine made observations were more objective and thus more reliable than human-made observations is discussed in Lorraine Daston and Peter Galison, 'The Image of Objectivity', in *Representations*, 40 (1992), pp. 81–128.
3 William Henry Fox Talbot, *The Pencil of Nature* (London, 1844–6).
4 William de Wiveleslie Abney, 'Photographic Operations in Egypt in Connection with the Late Transit of Venus', in *British Journal of Photography*, 22, no. 777 (26 March 1875), pp. 153–4.
5 These will be further discussed in the next chapter.
6 For instance, Ilford's and Kodak's involvement with the development of nuclear emulsions, see Peter Galison, *Image and Logic* (Chicago, IL, 1997), chap. 3.
7 M. Susan Barger and William B. White, *The Daguerreotype: Nineteenth-Century Technology and Modern Science* (Baltimore, MA, 2001), chap. 8.
8 It is quite possible that national pride played a role in elevating the daguerreotype above glass plate photography as the French method of choice.
9 Professor Jay M. Pasachoff, Williams College.
10 Stereo daguerreotypes of the transit were made on the French expedition headed by Admiral Mouchez.
11 Sir William de Wiveleslie Abney (1843–1920) was a photographic scientist and prolific photographic author who also contributed several improvements to photographic chemistry.
12 By 1872 Abney was in charge of all instruction in chemistry and photography at the School of Military Engineering at Chatham.
13 Abney, 'Photographic Operations in Egypt', p. 154.
14 12 December 1874, 'The Transit of Venus', in *The London Illustrated News*.
15 Abney, 'Photographic Operations in Egypt', p. 154.
16 Jessica Ratcliff, *The Transit of Venus Enterprise in Victorian Britain* (London, 2008), pp. 138–40.
17 August Hagenbach, *Photographische Methode zu Kontakt bestimmungen bei Sonnenfinsternissen* (Basel, 1912), p. 4.
18 C. F. Powell, P. H. Fowler and D. H. Perkins, *The Study of Elementary Particles by the Photographic Method. An Account of the Pricipal Techniques and Discoveries Illustrated by An Atlas of Photomicrographs* (London, 1959), p. 60.
19 See Lorraine Daston and Peter Galison, *Objectivity* (New York, 2007), chap. 2 and Martin Kemp, '"A Perfect and Faithful Record": Mind and Body in Medical Photography Before 1900', in *Beauty of Another Order*, ed. Ann Thomas (New Haven, CT, 1997), pp. 120–49.
20 This analogy was provided by Dr Mike Ware in a series of conversations about Raman plates and spectroscopy in general.
21 The negatives, prints and cameras are now in the Meydenbauer Archive in the Brandenburgisches Landesamt für Denkmalpflege, Waldstadt, about 30 km south of Berlin.
22 E.H.H., 'Review: Photographic Surveying', *The Geographical Journal*, 42, no. 2 (August 1913), p. 189.
23 The full details can be acquired at http://piccard.esil.univmed.fr/venus/missions/portugal/intro.html.
24 Jennifer Tucker, *Nature Exposed* (Baltimore, MD, 2005), pp. 5–10.

two: Photography and Experiment

1 Henri du Boistesselin, 'Photochimie et Photographie', *Le Radium*, vol. I, no. 1, July 1904, pp. 31–2 (p. 31).
2 J. B. Biot to W.H.F. Talbot, 24 February 1839. Talbot Correspondence Number 03817, http://foxtalbot.dmu.ac.uk, National Media Museum, 1937-4836. Daguerre claimed to have invented a sensitive paper as well, but the recipe that is currently known could not have produced a photochemical effect. Nonetheless, Biot appears to have successfully used a paper made by Daguerre.
3 Biot to Talbot, Monday 18 February 1839. Talbot Correspondence Number 03809, http://foxtalbot.dmu.ac.uk, National Media Museum, 1937-4835.
4 Physical Science Study Committee, *Physics* (Boston, MA, 1965).
5 Needless to say, there has been ample proof to the contrary on the issue of photography as art versus photography as mechanical copy.
6 Hundreds, if not thousands, of micro- and electron microscopic photographs of various emulsions in endless stages of exposure and development belong to this category (see illus. 11 and 5).

7 Emerson published this pamphlet privately in 1891. A detailed discussion of this story occurs in chapter Four.

8 There are histories written that tell the tale of the development of photography through emulsion development. Perhaps the most famous is by Kenneth Mees, the director of the Kodak Research Laboratory, but there are others by Robert Hunt, Neblette and Albert Londe.

9 Kelley Wilder and Martin Kemp, 'Proof Positive in Sir John Herschel's Concept of Photography', in *History of Photography*, 26, no. 4 (Winter 2002), pp. 358–66.

10 Larry J. Schaaf, *Out of the Shadows: Herschel, Talbot and the Invention of Photography* (New Haven, CT, 1992).

11 Peter Galison, *Image and Logic* (Chicago, IL, 1997), pp. 22–3.

12 The Étiquette Bleue, a gelatin-bromide emulsion, was the fastest plate commercially available at that time.

13 William Crookes, 'Radio-Activity of Uranium', in *Proceedings of the Royal Society of London*, 66 (1899–1900), pp. 409–23.

14 Antoine Henri Becquerel, *Recherches sur une propriété nouvelle de la matière: activité radiante spontanée ou radioactivité de la matière*, Mémoires de l'Académie Des Sciences de l'Institute de France series (Paris, 1903).

15 François Arago, 'Premier Mémoire sur la Photométrie; Démonstration Expérimentale de la Loi Du Carré Du Cosinus, 1850', in *Œuvres Complètes de François Arago*, M.J.-A. Barral (Paris and Leipzig, 1858), pp. 195–7.

16 Abney was an advocate for the use of these very fast plates in Britain, but progress was slow. Many photographers preferred dry collodion plates for their consistency and even for their low sensitivity, presumably being accustomed to the necessary exposure times.

17 Daniel Kaleman in correspondence.

18 For a complete discussion of the imaging decisions made by teams of scientists producing Hubble images, see Elizabeth A. Kessler's doctoral dissertation, 'Spacescapes: Romantic Aesthetics and the Hubble Space Telescope Images' University of Chicago, 2006, chap. 3.

19 C. F. Powell, P. H. Fowler and D. H. Perkins, *The Study of Elementary Particles by the Photographic Method. An Account of the Principal Techniques and Discoveries Illustrated by An Atlas of Photomicrographs* (London, 1959), pp. 11–19.

20 Michael Lynch and Samuel Y. Edgerton, Jr., 'Abstract Painting and Astronomical Image Processing', in Alfred I. Tauber, ed., *The Elusive Synthesis: Aesthetics and Science* (Dortrecht, 1996) pp. 103–24.

21 Fritz Brill, 'Gefilmte Vorgänge aus der Metall-Bearbeitung und – Prüfung', *Photographie und Wissenschaft*, v.3 n.3, 1954, p. 11.

22 Peter Galison has published an excellent study on the Emulsion Panel and its historical place in the politics of war, the imaging of science and atomic physics in Section 3.5, 'Kodak, Ilford, and the Photographic Emulsion Panel' in Galison, *Logic*, pp. 186–96.

23 Galison, *Logic*, p. 189.

24 Powell, Fowler, and Perkins, *Photographic Method*, pp. 62–3.

25 Harman Technology Limited, *Fact Sheet Ilford Nuclear Emulsions* (Knutsford, 2005), www.ilfordphoto.com.

three: Photography and the Archive

1 Jorge Luis Borges, 'On Exactitude in Science', in *Jorge Luis Borges: Collected Fictions*, trans. Andrew Hurley (New York, 1998), p. 325.

2 Paula Amad, 'Cinema's "Sanctuary": From Pre-Documentary to Documentary Film in Albert Kahn's Archives de la Planète (1908–1931)', *Film History*, XIII, no. 2 (2001), p. 139. For more on Kahn's archive see also Teresa Castro, 'Les Archives de la Planète a Cinematographic Atlas', *Jump Cut*, no. 48 (Winter 2006).

3 Amad, 'Cinema's "Sanctuary"', p. 138.

4 Elizabeth Edwards and Peter James, 'Surveying Our Past: Photography, History and Sir Benjamin Stone, 1897–1910', in *A Record of England: Sir Benjamin Stone and the National Photographic Record Association, 1897–1910*, Elizabeth Edwards and Peter James, with a foreword by Martin Barnes (Stockport, 2006), p. 7.

5 Oliver Wendell Holmes Holmes, 'The Stereoscope and the Stereograph', *Atlantic Monthly* III, no. 20 (June 1859), p. 748 For more on the USGS see especially chap. 3 of Robin Kelsey, *Archive Style: Photographs and Illustrations for U.S. Surveys, 1850–1890* (Berkeley, CA, 2007).

6 Even the type specimen, however, was subject to changing fashions in botany. In the nineteenth and twentieth centuries, a single type specimen was chosen even if it was not characteristic. This was then the officially named specimen. See Figure 2.27 and accompanying note in Lorraine Daston and Peter Galison, *Objectivity* (New York, 2007), p. 112.

7 The Man in the Moon, known in the story as Mein Herr, proudly recounts the superior mapping ability of his people, exemplified by a map 'on the scale of a mile to the mile!' in *Sylvie and Bruno Concluded*, first published in 1893. Needless to say this map was never used, instead 'we now use the country itself, as its own map, and I assure you it does nearly as well'.

8 It [AQ: the photographic archive?] is often also called the photographic document, and the two terms are here used interchangeably.

9 Akira Gomi has completed perhaps the largest body of work in this area, but Richard Avedon and Irving Penn are also well known for their use of this look.

10 Major Arthur George Frederick Griffiths, 'Anthropometry', in *The Encyclopaedia Britannica Eleventh Edition*, II (Cambridge, 1910), p. 119. Major Griffiths served as H. M. Inspector of Prisons between 1878 and 1896.

11 Elizabeth Edwards, *Raw Histories: Photographs, Anthropology and Museums* (Oxford, 2001), chap. 2.

12 Carl Victor Dammann, ed., *Anthropologisch-Ethnologisches Album in Photographien* (Berlin, 1873–4). It was completed by his brother Friedrich Wilhelm after Carl's death in 1874, and issued in a popular version in English as *The Races of Man: Ethnological Photographic Gallery of the Various Races* (London, 1875).

13 Malcolm Daniel and Barry Bergdoll, *The Photographs of Édouard Baldus* (New York, 1994).

14 See CERN, for instance, at www.cern.ch.

15 Kelsey, *Archive Style*, chap. 2.

16 Daston and Galison, *Objectivity*, p. 10.

17 Daston and Galison, *Objectivity*, p. 17.

18 Examples are the 'Digital Lunar Orbiter Photographic Atlas of the Moon', www.lpi.usra.edu/resources/lunar_orbiter/, or Edward Emerson Barnard's 'Photographic Atlas of Selected Regions of the Milky Way', www.library.gatech.edu/barnard/filename.

19 Edward Leaming, 'Note on the Photographic Technique', *Atlas of the Fertilization and Karyokinesis of the Ovum*, (New York, 1895).

20 For more on the issues of art and photography, and especially the issues of three dimensional works, see Geraldine Johnson, ed., *Sculpture and Photography: Envisioning the Third Dimension* (Cambridge, 1998).

21 It is commonly asserted that photography records *all* the details, but we know that this is patently untrue. Photographic films can be made that exclude anything from yellow light in the visible spectrum to ultraviolet radiation.

four: Art and the Scientific Photograph

1 James Elkins, 'Art History and Images That Are not Art', *Art Bulletin*, 77 (December 1995), p. 556.

2 An overview of the arguments and a useful bibliography are provided in Linda Dalrymple Henderson, 'Editor's Introduction: 1. Writing Modern Art and Science - an Overview; II. Cubism, Futurism, and Ether Physics in the Early Twentieth Century', *Science in Context*, XVII, no. 4 (2004), pp. 423–66.

3 Aaron Scharf, *Art and Photography* (New York, 1968), title page.

4 Information and galleries can be found at www.nikonsmallworld.com/index.php.

5 D'Arcy Wentworth Thompson, *On Growth and Form* (Cambridge, 1917). Also see Gyorgy Kepes, ed., *Structure in Art and in Science*, Vision and Value Series (New York, 1965).

6 Karl Blossfeldt, *Urformen der Kunst* (Berlin, 1928).

7 Gert Mattenklott, *Karl Blossfeldt: Urformen der Kunst Wundergarten der Natur Das fotografische Werk in einem Band* (Munich, 1994), pp. 21–2. Blossfeldt was a lecturer until 1921, when he received a professorship, and continued teaching until his retirement in 1930, just two years before his death.

8 The glass plates are held in the Karl Blossfeldt Archive, Ann and

Jürgen Wilde, Zülpich.

9 Originally published as László Moholy-Nagy, *Malerei, Fotografie, Film* (Munich, 1925).

10 Oliver A. I. Botar, 'László Moholy-Nagy's New Vision and the Aestheticization of Scientific Photography in Weimar Germany', *Science in Context*, XVII, no. 4 (2004), p. 529.

11 This is also true of Claudia Terstappen's photographs of the Berlin Museum of Natural History (see illus. 9).

12 His conviction is rather suspect, since he continued to make photographs after coming to these conclusions.

13 Vero C. Driffield, *Control of the Development Factor and a Note on Speed-Determination* (London, 1903).

14 Evans photographed in the same time period Ernst Haeckel was working on his seminal treatise on the forms in nature, *Kunstformen der Nature*.

15 Frederick H. Evans, 'Photo Micrography', *Photographic Journal*, n. s., II/3 (31 December 1886), pp. 25–8.

16 George Smith made the Woodburytypes from negatives supplied by Evans.

17 Frederick H. Evans, 'Glass Versus Paper', *Camera Work*, no. X (April 1905), p. 36.

18 Katy Barron, Anna Douglas, and Martin Barnes, *Alchemy* (London, 2006).

19 Mark Klett et al., *Second View: The Rephotographic Survey Project* (Albuquerque, 1984) The project continued in 1999 in Third View, which, along with the photographs from *Second View*, can be seen at www.thirdview.org.

20 Klett, *Second View*, 41.

21 This has now been done by Robin Kelsey in Robin Kelsey, *Archive Style: Photographs and Illustrations for US Surveys, 1850–1890* (Berkeley, CA, 2007).

Select Bibliography

Abney, William de Wiveleslie, 'Photographic Operations in Egypt in Connection with the Late Transit of Venus', *British Journal of Photography*, XXII, no. 777 (26 March 1875), pp. 153–4

Amad, Paula, 'Cinema's "Sanctuary": From Pre-Documentary to Documentary Film in Albert Kahn's Archives de la Planète (1908–1931)', *Film History*, XIII, no. 2 (2001), pp. 138–59

Arago, François, 'Fixation des images qui se forment au foyer d'une chambre obscure', *Comptes Rendus*, VIII, no. 1 (7 January 1839), pp. 4–7

—, 'Premier Mémoire sur la Photométrie; Démonstration Expérimentale de la Loi Du Carré Du Cosinus, 1850', in *Œuvres Complètes de François Arago*, M.J.-A. Barral (Paris and Leipzig, 1858), pp. 168–215

Barger, M. Susan and William B. White, *The Daguerreotype: Nineteenth-Century Technology and Modern Science* (Baltimore, MD, 2001)

Barron, Katy, Anna Douglas and Martin Barnes, *Alchemy* (London, 2006)

Becquerel, Antoine Henri, *Recherches sur une propriété nouvelle de la matière: activité radiante spontanée ou radioactivité de la matière*, Mémoires de l'Académie Des Sciences de l'Institute de France series (Paris, 1903)

Blossfeldt, Karl, *Urformen der Kunst* (Berlin, 1928)

Borges, Jorge Luis, 'On Exactitude in Science', *Jorge Luis Borges: Collected Fictions*, trans. Andrew Hurley (New York, 1998), p. 325

Botar, Oliver A. I., 'László Moholy-Nagy's New Vision and the Aestheticization of Scientific Photography in Weimar Germany', *Science in Context*, XVII, no. 4 (2004), pp. 525–56

Canguilhem, Denis, *Le Merveilleux scientifique. Photographies du monde savant en France, 1844–1918* (Paris, 2004)

Castro, Teresa, 'Les Archives de la Planète a Cinematographic Atlas', *Jump Cut*, XLVIII (Winter 2006)

Crookes, William, 'Radio-Activity of Uranium', *Proceedings of the Royal Society of London*, LXVI (1899–1900), pp. 409–23

Dammann, Carl Victor, ed., *Anthropologisch-Ethnologisches Album in Photographien* (Berlin, 1873–9)

Daniel, Malcolm, and Barry Bergdoll, *The Photographs of Édouard Baldus*, exh. cat., Metropolitan Museum of Art (New York, 1994)

Darius, Jon, *Beyond Vision* (Oxford, 1984)

Daston, Lorraine, and Peter Galison, 'The Image of Objectivity', *Representations*, XL (1992), pp. 81–128

—, *Objectivity* (New York, 2007)

Driffield, Vero C., *Control of the Development Factor and a Note on Speed-Determination* (London, 1903)

Edwards, Elizabeth, *Raw Histories: Photographs, Anthropology and Museums* (Oxford, 2001)

Edwards, Elizabeth, and Peter James, 'Surveying Our Past: Photography, History & Sir Benjamin Stone, 1897–1910', *A Record of England: Sir Benjamin Stone and the National Photographic Record Association, 1897–1910*, Elizabeth Edwards, Peter James, with a foreward by Martin Barnes (Stockport, UK, 2006), pp. 7–24

Elkins, James, 'Art History and Images That Are Not Art', *Art Bulletin*, LXXVII (December 1995), pp. 553–71

Evans, Frederick H., 'Glass Versus Paper', *Camera Work*, X (April 1905), pp. 36–41

—, 'Photo Micrography', *Photographic Journal*, n. s., II/3 (31 December 1886), pp. 25–8

Galison, Peter, *Image and Logic* (Chicago, IL, 1997)

—, *How Experiments End* (Chicago, IL, 1987)

Gribbin, John, *In Search of Schrödinger's Cat: Quantum Physics and Reality* (London, 1984)

Griffiths, Major Arthur George Frederick, 'Anthropometry', *The Encyclopaedia Britannica*, Eleventh Edition, vol. II (Cambridge, 1910), pp. 119–20

Hagenbach, August, *Photographische Methode zu Kontakt-bestimmungen bei Sonnenfinsternissen* (Basel, 1912)

Henderson, Linda Dalrymple, 'Editor's Introduction: I. Writing Modern Art and Science – an Overview; II. Cubism, Futurism, and Ether Physics in the Early Twentieth Century', *Science in Context*, XVII, no. 4 (2004), pp. 423–66

Holmes, Oliver Wendell Holmes, 'The Stereoscope and the Stereograph', *Atlantic Monthly*, III, no. 20 (June 1859), pp. 738–48

Johnson, Geraldine, ed., *Sculpture and Photography: Envisioning the Third Dimension* (Cambridge, 1998)

Kelsey, Robin, *Archive Style: Photographs and Illustrations for US Surveys, 1850–1890* (Berkeley, CA, 2007)

Kemp, Martin, '"A Perfect and Faithful Record": Mind and Body in Medical Photography Before 1900', *Beauty of Another Order*, ed. Ann Thomas (New Haven, CT, 1997), pp. 120–49

—, *The Science of Art* (London, 1990)

Kepes, Gyorgy, ed., *Structure in Art and in Science*, Vision + Value Series (New York, 1965)

Klett, Mark et al., *Second View: The Rephotographic Survey Project* (Albuquerque, NM, 1984)

Klonk, Charlotte, *Science and the Perception of Nature: British Landscape Art in the Late Eighteenth and Early Nineteenth Centuries* (New Haven, CT, 1996)

Mattenklott, Gert, *Karl Blossfeldt: Urformen der Kunst Wundergarten der Natur Das fotografische Werk in einem Band* (Munich, 1994)

Moholy-Nagy, László, *Malerei, Fotografie, Film* (Munich, 1925)

Physical Science Study Committee, *Physics* (Boston, MA, 1965)

Powell, C. F., P. H. Fowler and D. H. Perkins, *The Study of Elementary Particles by the Photographic Method. An Account of the Principal*

Techniques and Discoveries Illustrated by An Atlas of Photomicrographs (London, 1959)

Ratcliff, Jessica, *The Transit of Venus Enterprise in Victorian Britain* (London, 2008)

Schaaf, Larry J., *Out of the Shadows. Herschel, Talbot and the Invention of Photography* (New Haven, CT, 1992)

Scharf, Aaron, *Art and Photography* (New York, 1968)

Sandweiss, Martha A., *Print the Legend: Photography and the American West* (New Haven, CT, 2002)

Talbot, William Henry Fox, *The Pencil of Nature* (London, 1844–6)

Thomas, Ann, ed., *Beauty of Another Order* (New Haven, CT, 1997)

Thompson, D'Arcy Wentworth, *On Growth and Form* (Cambridge, 1917)

Tucker, Jennifer, *Nature Exposed* (Baltimore, MD, 2005)

Wilder, Kelley, and Martin Kemp, 'Proof Positive in Sir John Herschel's Concept of Photography', *History of Photography*, XXVI, no. 4 (Winter 2002), pp. 358–66

Acknowledgements

My colleagues at the Max Planck Institute for the History of Science in Berlin are most deserving of thanks for sharing their knowledge and criticism during the writing of this book. Susan Barger, Martin Barnes, Charlotte Bigg, Mario Brandhorst, Elizabeth Edwards, Gregg Mitman, Tania Munz, Sarah de Rijcke, Michael Taylor, Janet Vertesi, and Mike Ware gave valuable advice and criticism on drafts of various chapters and David Exton and Adrian Whicher of the Science Museum, London donated generous hours to answering my questions and aiding my search for photographs. I am deeply grateful for the tireless research and organizational skills of Sara Stukenbrock, without whom nothing would have been done. I would like to thank series editor Mark Haworth Booth, and Reaktion's Vivian Constantinopoulos for their patience and support. And finally, I would like to thank my family, for whom this book was written in the hope that it might explain what I do. *Photography and Science* is dedicated to Clara, who unwittingly influenced so much of it.

Photo Acknowledgements

The author and publishers wish to express their thanks to the following sources of illustrative material and/or permission to reproduce it:

In *Annalen der Physik und Chemie*, vol. 68 (Leipzig, 1899): 5; Archive of the Kunsthistorisches Institut, Florence: 62; in *Oeuvres complètes de François Arago*, vol. 2 (Leipzig, 1858): 43; courtesy Subhankar Banarjee: 70; courtesy Dr Susan Barger: 11; in Edward E. Barnard, Mary Ross Calvert, Edwin Brant Frost, eds: *A Photographic Atlas of Selected Regions of the Milky Way* (Washington, DC: Carnegie Institution, 1927): 29; in Anton Blümel, *Über elektrische Entladungsfiguren auf photographischen Platten* (Berlin: R. Gärtners Verlagsbuchhandlung, 1898): 3; Brandenburgisches Landesamt für Denkmalpflege, Waldstadt: 24; courtesy Andrew Davidhazy: 47; courtesy Susan Derges: 68; in René Descartes, *Discours de la méthode . . .* (Leiden, 1637): 2; Deutsches Museum, Munich: 55; courtesy Dr Pierre Drap, Project coordinator, CNRS: 26; George Eastman House (International Museum of Photography and Film), Rochester, NY: 65 (Evans Album), 76; in Galton, *Inquiries into Human Faculty and its Development* (London: Macmillan & Co, 1883): 31; photo courtesy Global Observatory for Ecosystem Services, Tropical Rain Forest Information Center / Landsat.org, Michigan State University, East Lansing, MI: 50, 51; courtesy Leon Golub and Jay Pasachoff: 13; courtesy Göttingen University Library: 42; in Hagenbach, *Photographische Methode zu Kontakt-bestimmungen bei Sonnenfinsternissen, Naturforschenden Gesellschaft*, vol. 23 (Basel: Emil Birkhänser, 1912): 15; in *Handbuch der Experimentalphysik*, vol. 22, p. 416 (Leipzig: Akademische Verlagsgesellschaft, 1929): 20; Herzog August Bibliothek, Wolfenbüttel: 2; Ingleby Gallery, Edinburgh: 71; Karl Blossfeldt Archiv, Ann and Jürgen Wilde, Zülpich: 66; courtesy Mark Klett: 78, 79 80, 81; in Kolle and Wassermann, *Handbuch der pathogenen Mikroorganismen* (Jena: Verlag Gustav Fischer, 1902): 28; courtesy Hans P. Kraus, Jr: 34, 41, 52; in Thierry Lefebvre, Jacques Malthête, Laurent Mannoni, eds, *Lettres d'Étienne-Jules Marey à Georges Demenÿ 1880–1894* (Paris: AFRHC, 1999): 64; Library of the Paris Observatory: 16; courtesy Michael J. Marshall: 69; in *Mémoires de L'Académie des Sciences de l'Institut de France*, vol. 46 (Paris: Firmin-Didot & Co., 1903): 37, 39; Metropolitan Museum of Art, New York: 58; courtesy Daro Montag and Purdy Hicks Gallery, London: 77; in Ernest A. B. Mouchez, *La Photographie Astronomique à l'Observatoire de Paris et la Carte du Ciel* (Paris: Gauthier-Villars, 1887): 8, 10, 53; courtesy MPIWG library, Berlin: 3, 5, 8, 10, 28, 29, 37, 39, 40, 43, 44, 53, 54, 59, 60, 61; NASA / ESA / M. Robberto (Space Telescope Science Institute / ESA) and the Hubble Space Telescope Orion Treasury Project Team: 46; National Media Museum, Bradford: 19; National Science Museum, London: 38 (1915-312 Pt 2, made for the paper entitled *Radioactivity of Uranium*, read before the Royal Society, 10 May 1900), 72; *Nature*: 6 [in vol. 52, no. 1341 (11 July 1895)], 7 [in vol. 223, no. 5208 (23 August 1969)], 27 [in vol. 65, no. 1671 (7 November 1901)]; in Physical Science Study Committee, *Physics* (2nd edn, Boston: Heath, 1965): 35; in Powell, *The Study of Elementary Particles by the Photographic Method* (New York: Pergamon Press, 1952): 17, 48, 49; in *Le Radium – La Radioactivité et les Radiations*: 40 (vol. 1, no. 3), 44 (vol. 2, no. 3); © Robert Rauschenberg / VG Bild-Kunst, Bonn: 73; reproduced by permission of the Master and Fellows of St John's College, Cambridge: 36; Aaron Scharf, *Art and Photography* (Baltimore: Penguin, 1974): 63; courtesy Robert Schlaer: 12; courtesy Science and Technology Facilities Council, Swindon: 14; Société Française de Photographie, Paris: 25; courtesy Dr Taylor, New Zealand: 22, 23; courtesy Claudia Terstappen: 9; in *The Theory of the Photographic Process* (New York: The Macmillan Co, 1942): 75; in *Urformen der Kunst* (Berlin: Ernst Wasmuth Verlag, 1928): 66; Victoria & Albert Museum, London (photos V&A Images): 30, 45, 67; courtesy of von Hippel family: 74; Wellcome Library, London: 1, 4, 31, 32, 33, 56; in Edmund B. Wilson, *An Atlas of the Fertilization and Karyokinesis of the Ovum* (New York: Columbia University Press, 1895): 60, 61.

Index